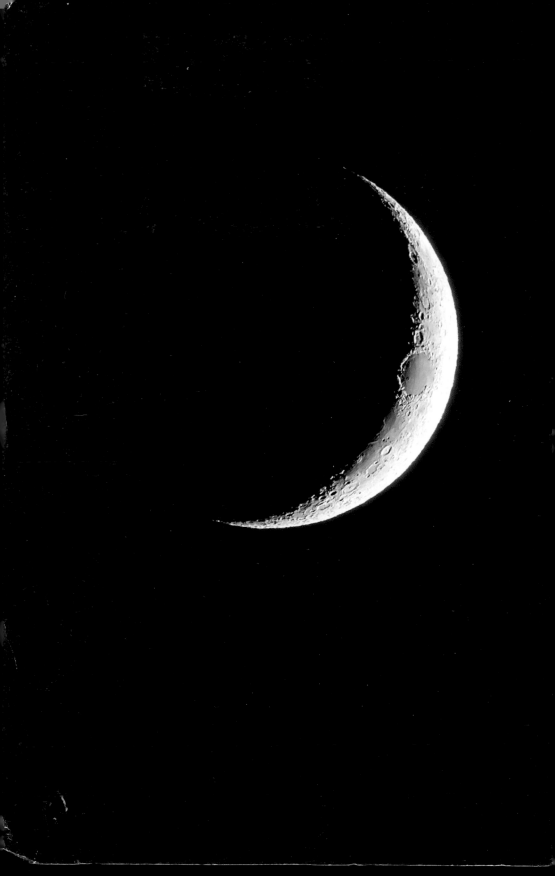

Photography
NIGHT SKY

A Field Guide
for Shooting
After Dark

JENNIFER WU AND
JAMES MARTIN

MOUNTAINEERS
BOOKS

TO YOU, PHOTOGRAPHERS OF THE NIGHT

ᗰ

MOUNTAINEERS BOOKS

Mountaineers Books is the publishing division of The Mountaineers, an organization founded in 1906 and dedicated to the exploration, preservation, and enjoyment of outdoor and wilderness areas.

1001 SW Klickitat Way, Suite 201 • Seattle, WA 98134
800.553.4453 • www.mountaineersbooks.org

Printed in China

Distributed in the United Kingdom by Cordee, www.cordee.co.uk
17 16 15 14 1 2 3 4 5

Copy editor: Anne Moreau
Cover design and layout: Peggy Egerdahl
Cover photograph: *Shooting star over Half Dome, Yosemite National Park, California. f/1.4, 20 seconds, ISO 1600, 24mm, Canon EOS 5D Mark II.*
Frontispiece: *Crescent moon photographed in Yosemite National Park, California. f/5.6, 1/30 second, ISO 640, 800mm, Canon EOS 5D Mark II.*
All photographs by Jennifer Wu unless otherwise noted

Library of Congress Cataloging-in-Publication Data
Wu, Jennifer.
 Photography night sky : a field guide for shooting after dark / Jennifer Wu and James Martin.
 pages cm
 Includes index.
 ISBN 978-1-59485-838-3 (paperback)—ISBN 978-1-59485-839-0 (ebook)
 1. Astronomical photography—Handbooks, manuals, etc. 2. Night photography—Handbooks, manuals, etc. I. Martin, James, 1950- II. Title. III. Title: Night sky.
 QB121.W8 2014
 522'.63–dc23

 2013028305

ISBN (paperback): 978-1-59485-838-3
ISBN (ebook): 978-1-59485-839-0

CONTENTS

PREFACE

As a landscape photographer, I've spent hundreds of nights sleeping under the stars. I enjoy moonrise and moonset—the full moon hanging like a lantern over the horizon or the first crescent of the lunar cycle chasing the sunset. However, I love most the glowing Milky Way slicing through the midsummer sky. That dusting of stars, a minuscule fraction of the hundred million in our galaxy, is enough to bring forth the deepest questions of existence and ignite a love of the great beauty of the universe.

I wanted to capture that beauty and splendor with my camera, to place the darkened landscape against the bright stars of the night sky. My early attempts left much to be desired, but over time each issue I encountered was resolved to my satisfaction. I began to create images that approached what I was looking for in night sky images. Star photography, I found, allows us to see more deeply into the galaxy. Hidden colors are revealed, and stars too dim for the human eye to perceive appear like magic in the image.

The book you hold is the result of James Martin's suggestion that I write on the subject of night sky photography. I liked the idea of explaining the issues and techniques particular to capturing the night sky, so we agreed to collaborate.

It was by trial and error that I discovered how to photograph the stars as points of light as I was not shown by anyone how to do that. The results of those experiments are the foundation of this book. They are the techniques I find that work best, at least to my taste. Photography is about personal vision. This book is a toolbox; use the tools as you see fit. I won't be bothered if you prefer a different color balance or opt for a greater sense of motion in star fields than I. My hope is that you will find a vision of your own, enjoy the creative process, and share the beauty of the night landscape with others.

Jennifer Wu

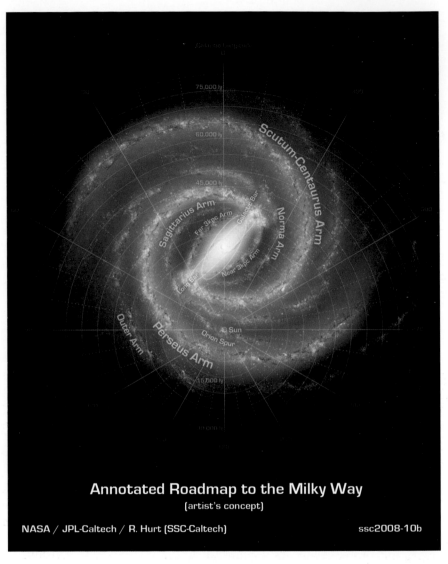

Annotated Roadmap to the Milky Way

(artist's concept)

NASA / JPL-Caltech / R. Hurt (SSC-Caltech) ssc2008-10b

This artist's concept illustrates the Milky Way's elegant spiral structure as dominated by two arms. Courtesy NASA/JPL-Caltech/R. Hurt (SSC/Caltech)

INTRODUCTION

Our planet sits on the outer edge of the Milky Way galaxy, a pin-wheeling disk composed of 200 billion to 400 billion stars, one galaxy among hundreds of billions. However, we can see only a few thousand at a time with the naked eye. Because we are near the edge of this rotating disk, we're moving fast, about half a million miles an hour. Even so, it takes 225 million years for the galaxy to complete one revolution.

The densest concentration of stars is in the middle of the disk, about 30,000 light-years away. When we say we are looking at the Milky Way, we mean the band of the greatest density. Every star we see is part of our galaxy.

As the earth orbits the sun, we see different parts of the sky. In winter in North America, we look toward the outer edges, with few stars that are set away from the center, and the sun and its light masking the glowing heart of the galaxy. However, in June, July, and August, we look to the area with the densest concentration of stars and gasses—so many stars we can't tell them apart.

If you look up from the North Pole on a clear winter's night, you can watch the North Star floating immobile in the sky. A time-lapse would show the constellations spinning around it counterclockwise. Halfway to the equator, at the 45th parallel—which is roughly the latitude of Portland, Oregon; Minneapolis; and Milan—the North Star is halfway between the horizon and the point directly above your head. Just north of the equator, it would skim along the horizon. An hours-long exposure of the night sky captured photographing straight up from the South Pole would look like concentric circles. A time-lapse would show the stars traveling clockwise.

The stars provide a wonderful backdrop for night photography, but the sky abounds with other objects and phenomena. Meteors streak across the sky. Comets orbit the sun from the farthest reaches of the solar system, their tails pointing away from the sun whether coming or going. Auroras flame and dance at the poles. The Belt of Venus paints the horizon pink for mere minutes each twilight. The moon shifts its shape day by day. Learning the art of photographing at night will allow you to capture the beauty of these celestial visions.

THE ART OF NIGHT SKY PHOTOGRAPHY

Photographing the night sky can challenge the most accomplished photographer. We constantly battle the laws of physics, the limitations of equipment, ever-changing weather, and the intrusions of other people. Digital sensors generate noise during long exposures, clouds and dew obscure the stars, passing headlights blow out foregrounds, and some nights grow exceedingly cold, draining batteries and numbing fingers. In this book we will look at how to overcome the challenges of technology, weather, and darkness.

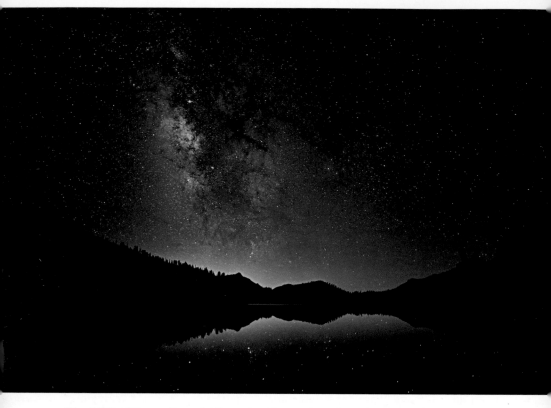

The Milky Way reflected, Yosemite National Park, California. f/1.4, 20 seconds, ISO 1600, 24mm, Canon EOS 5D Mark II.

Still, when properly done, the rewards are worth all the effort. With a long exposure, the sensor picks up faint stars, invisible to the naked eye, as they glitter like diamond dust. Star trails revolving around the North Star (Polaris) testify to the rotation of the globe. The sensor captures the last tints of twilight glow on the horizon, grading from red to cobalt blue.

During one of my first nights photographing the Milky Way, I noticed more stars on the LCD than I saw looking at the sky. Puzzled, I tried an experiment. I photographed a dark area between two bright stars and viewed the image. There were so many stars I was amazed. Because a camera's sensor picks up more light than our eyes, the possibilities for photographing the Milky Way and the stars—for creating fantastic views of the sky—far exceed what strikes the naked eye. The Milky Way looks like a white band of light to our eyes, but the camera picks up even more stars as well as the gasses we cannot see.

As you photograph at twilight and at night, you'll come to recognize the best moment to photograph as the color of the sky changes. You'll know by glancing at a photograph of the Milky Way in what season the image was captured. You'll recognize scenes that could become great foregrounds, visualizing

how the stars would work as a background. Shutter speed, ISO, and color temperature change shot to shot within a narrow range, and the techniques needed to create a competent photograph are easy to grasp. The art of night sky photography centers on how to bring an image to life—to meld foreground and stars into a striking composition.

ABOUT THE BOOK

This book concentrates on photographing four principal subjects: stars as points of light, star trails, the moon, and twilight. These subjects share common techniques and considerations, but each requires a distinct approach. In addition, the book will cover techniques for photographing other phenomena in the night sky such as auroras, meteors, and false dawns.

Once captured, the images need to be processed on the computer, a practice we call post-processing. The settings and post-processing procedures that can lift an image from mundane to striking are presented at the end of the book. Impeccable technique is not enough. Strive to elevate your photography conceptually as well. Applying a few simple compositional precepts can transform a lifeless snapshot into a dynamic photograph.

Look for sidebars with tips, checklists to help you organize a seamless shoot, and extra information in "Shooting with Jennifer" sidebars to spur your progress and inspire your work. Bookmark the checklists for easy reference when you are getting prepared or are out in the field.

1

COMPOSITION

Opposite: *Crescent moon placed between the branches of the dead tree in silhouette at twilight, White Mountains, California. f/22, 10 seconds, ISO 100, 24–70mm at 70mm, Canon EOS 5D.*

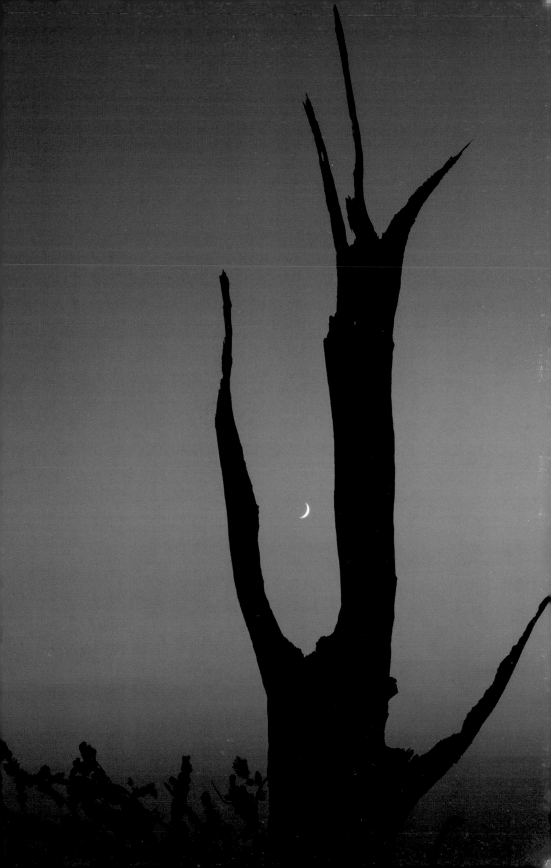

Creative composition makes the photograph compelling while technique merely unveils the composition. A perfectly exposed, impeccably sharp image means nothing unless the photograph presents a strong arrangement of compositional elements.

Composition is doubly important when photographing the night sky to avoid repetition and monotony. One tight shot of a full moon looks like another. A perfectly exposed image of the Milky Way resembles all that went before. Even if our galaxy almost fills the frame, it serves as context. The other elements make the shot.

DEFINING THE SUBJECT

As the Milky Way emerges from the horizon, it defines a band across the sky that leads the eye across the frame. Including within the frame the intersection of the Milky Way and the earth's horizon grounds the image and makes it more balanced. Light pollution from a distant city provides a pleasing, warm glow on the horizon that mimics the sunset, contrasting with the cooler palette of the night sky.

Photograph both horizontal and vertical images. You may prefer one way in the field but see merit in the other when reviewing your images at home. A horizontal image works well to emphasize the features in the landscape or the Milky Way when it arches across the sky. A vertical image works well when you have a tall tree in the foreground or when the Milky Way is a diagonal in the sky. The latter composition places emphasis on the Milky Way as the main subject in the scene.

Panoramas of the night sky can present a dramatic view by including more of the Milky Way and the grandeur of the landscape. The large digital file will make a really big print. See "Panoramas" in chapter 6.

FRAMING AT NIGHT

Framing in the dark is a challenge. If possible, scout your location in daylight, when it's easier to find good foregrounds. Determine your lens choice and imagine a star-filled sky. Look for subjects that work well as a silhouette. Take a few test shots with different focal lengths to determine composition and the best lens choice for the scene. Mark the best site with a pile of rocks, a teepee of branches, or any other object you can locate in the dark. A GPS can lead you to the right place and help you get back as well.

During the day you see the clutter and dead branches, but at night the darkness reveals just the silhouette, making it a more appealing photograph. It is easy to look for subject-defined images by day; however, at night, focus on the form and shape instead of the subject to help envision what it will look like as a silhouette. At first you may not be able to imagine what it will look like at night, but after you have some experience of photographing at night you will see with new vision.

Bring a compass with you during the day to help orient yourself so you can figure out where the Milky Way, auroras, or the moon will be in relation

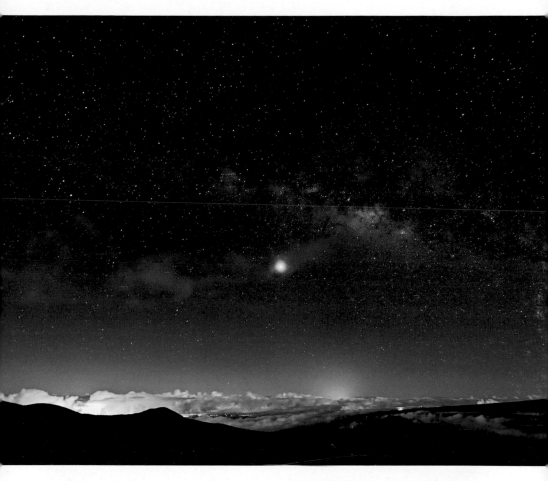

Big Island of Hawaii. The Milky Way, seen as a band across the sky with an erupting volcano in the distance, creates the reddish glow in the sky. The yellow glow comes from the city of Hilo. The low diagonal band of the Milky Way lends itself to a horizontal composition and the 16mm lens allows for more of the Milky Way and sky to be included. f/2.8, 30 seconds, ISO 3200, 16–35mm II lens set to 16mm, Canon EOS-1Ds Mark III.

to the scenery when you return at night. Plan to photograph in the direction of your foreground subject or in the direction where the landscape is lit by the moon. A number of programs, apps, and websites show where the moon will rise and set and the position of the Milky Way for any given location and date. See "Preliminary Research" in chapter 3, and Resources at the end of the book.

While making your test exposure at night, compose the image in the frame. With each new image, adjust the composition and straighten the horizon line if needed.

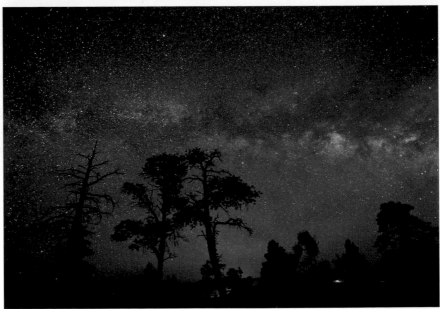

I scouted the area during the day looking for trees to shoot against the sky as silhouettes, and returned at night. Photographed at Bryce Canyon National Park, Utah. Night image at f/1.8, 20 seconds, ISO 4000, 24mm lens, Canon EOS 5D Mark III.

SHOOTING WITH JENNIFER

When photographing the Grand Tetons near the full moon, the landscape was so brightly lit I didn't need a flashlight to see the path. After the moon set however, I really wanted it. Earlier that day I had seen a bear, river otters, and elk in the same location. They did not seem bothered by my presence or the presence of other photographers when I shot there at sunrise. That night an elk barked as I photographed, and I heard the sound of hooves pounding. I didn't feel welcome! I had already taken this shot of the mountains and sky, so I left the elk to its nighttime contemplation of the stars.

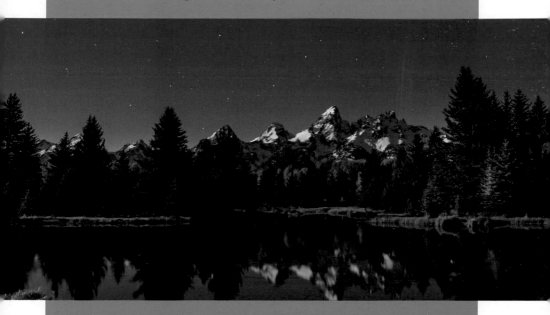

Stars two nights before the full moon at Schwabacher's Landing, Grand Teton National Park, Wyoming. I originally shot this as all sky, but it was not as compelling because of the large area of the sky with few stars. I cropped the sky and included the landscape, making the subject of the photo the moonlit landscape supported by the stars as the background element. f/3.5, 25 seconds, 24–70mm lens at 27mm, Canon EOS-1Ds Mark III.

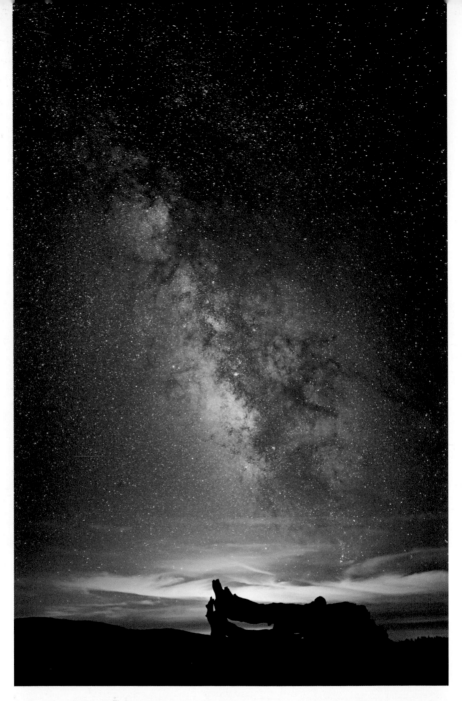

Log and Milky Way at Yosemite National Park, California. Since the Milky Way and stars can look the same, I look for an interesting foreground such as a log, tree, or boulders to make it different. The vertical composition places emphasis on the Milky Way as the main subject. The warm glow in the distance is ambient city light. f/1.4, 20 seconds, ISO 1600, 24mm lens, Canon EOS 5D Mark II.

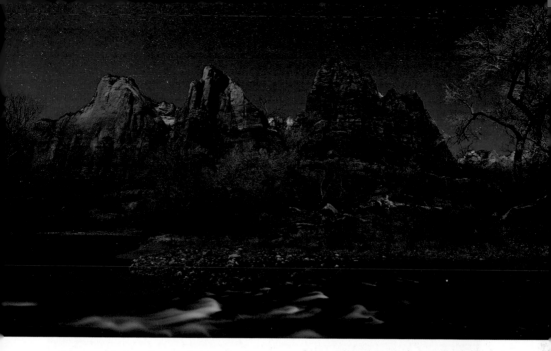

Stars with foreground lit by a half-moon at Zion National Park, Utah. There is not much going on in the sky with the bright moon, so I did not include much of it. Additionally, the horizontal composition works to emphasize the landscape over the sky. f/2.8, 30 seconds, ISO 1600, 16–35mm II lens set to 16mm, Canon EOS-1Ds Mark III.

Establishing a straight horizon may require extra care because the black foreground blends in with the dark sky. Some cameras feature horizontal and vertical levels displayed on the LCD. Absent that, a bubble level that fits in the hot shoe is an effective substitute. (Some bubble levels are misaligned. Check yours for accuracy before trusting it.) Use a small red flashlight—red light preserves night vision—or a dim headlamp to light the bubble level from behind to see if your horizon line is straight.

Trust your eye and experience. Even if the bubble level shows that a horizon that appears tilted is straight, frame it in the way pleasing to your eye, especially when working with a slightly unlevel horizon line such as a mountain slope or curving shoreline angling toward one edge of the frame.

Bubble level

19

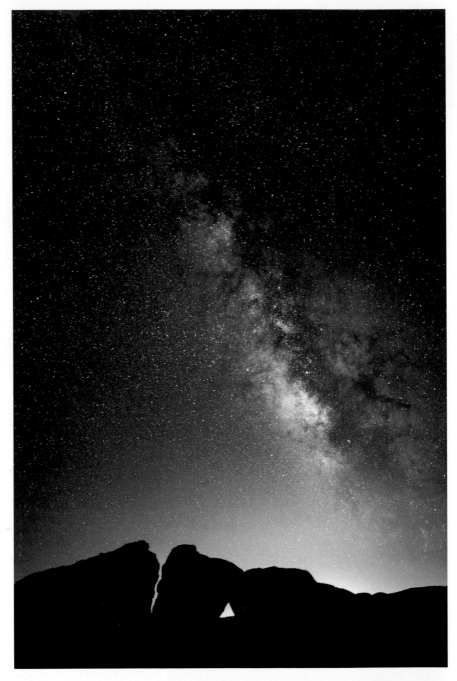

Silhouetted boulders are used as a foreground element to provide interest. Yosemite National Park, California. f/1.4, 20 seconds, Yosemite National Park, California. ISO 1600, 24mm lens, Canon EOS 5D Mark II.

ESTABLISHING THE FOREGROUND

While stars may dominate the image, the foreground anchors the composition. No matter how dramatic the sky, without a foreground, one image of the stars looks like any other. Look for a strong foreground element such as a gnarled tree, an interesting dark building, boulders, or a reflecting lake. The hyper-real blizzard of stars arcing across the sky may make viewers gasp, but it is the foreground that defines the composition.

At the very least, make sure that the silhouette of the earth runs along the bottom of the frame to place the empty, black foreground in context. Beginning nighttime photographers often have too much black space in the foreground, so tip the front of the camera up to eliminate that mistake.

LIGHT-PAINTING THE FOREGROUND

When photographing stars, we are limited to framing; however, we can let our imagination loose by illuminating the foreground with light-painting, that is, illuminating an area or an object with an artificial light. Any hand-held light source, kept outside the frame, can add definition to a foreground. Try candles, car headlights, taillights, campfires, red and green laser pointers, strobes, Speedlight devices, sparklers, glow sticks, LED arrays, lanterns, and

A single red LED in a headlamp illuminated this abandoned bank building in Rhyolite, Nevada, in just 10 seconds twenty feet from the base of the building. Bathing the building with 20 seconds of light made it look garish. f/1.4, 10 seconds, ISO 3200, 24mm lens, Canon EOS 5D Mark II.

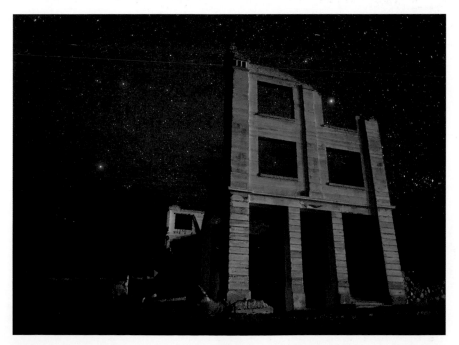

flashlights. Each has its own color temperature—yellowish for a normal flash-light, bluish for an LED headlamp, white for a Speedlight. You can bathe your foreground in warm, even light or set up multicolored spotlights. You can "draw" on a tree with a flashlight. Change the color of the source with col-ored gels, available at any professional camera store. Roscolux's swatch book sampler has many colors, and the gels will fit over a flash or small flashlight. Attach the gel with gaffer's tape. Use some heavy, yellow warming filters over a headlamp (blue light) to neutralize the color. Diffuse the light to produce a more even effect. Passing the light through tissue paper, a white handkerchief, or a square of white silk smoothes the effect and reduces the brightness. The little white bags placed in airline seat pockets for distressed passengers also do the trick better than most other diffusion methods.

When changing the color of an image, such as adding blue for night images to artificially make the sky blue as it is naturally brownish yellow, all colors in the color wheel will shift toward that color. For night photography of the stars, yellow will move to blue and thus cancel out the yellow color creating a more neutral tone closer to white. Red will move to pink and so on.

CREATE A BASE LAYER

When light-painting, be sure to start out by taking one image without any light-painting in it. This will be your base layer. That way you don't need to worry about getting the light just on the subject. If you happen to get light on the other areas and don't want it there, you can use the areas of the non-light-painted photograph to cover that up in the post-processing stage.

ADD COLOR

You can paint with one color, take another photograph, paint with another color, and keep building up your image until you get all the colors you want. Try it with several colors. For example, paint a window green and the door-way red, or paint one branch of a tree one color and another branch another color. Have fun!

Color wheel.

ADJUST THE LIGHT INTENSITY

How much light can you use? Increasing the distance from a light source requires adding more light for the same amount of illumination, either by increasing the length of the exposure or the power of the light. The inverse square law states that doubling the distance cuts the light intensity by a factor of four. So, if lighting a car with a flashlight from 10 feet away requires 5 seconds at a

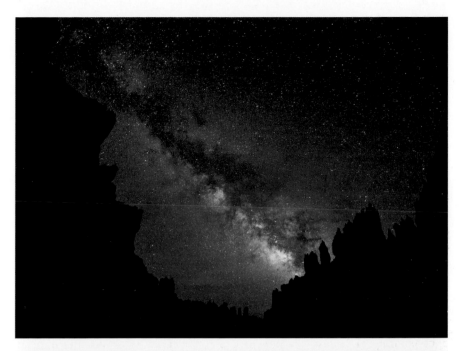

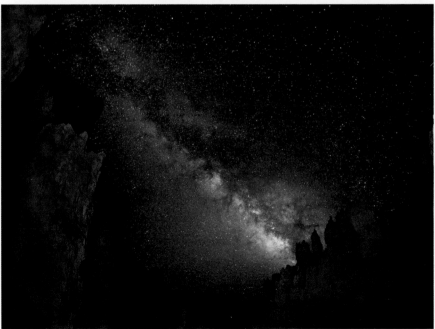

Two photographs taken at Bryce Canyon National Park, Utah. The image on the bottom used light-painting for 20 seconds on the canyon walls. Both images f/2.8, 25 seconds, ISO 6400, 15mm lens, Canon EOS 5D Mark III.

Ghost towns and abandoned cars make excellent subjects for light-painting. Below: The general store at Rhyolite, Nevada, featuring side lighting and frontal lighting. The side lighting provides a more compelling composition as it adds shadows and texture.

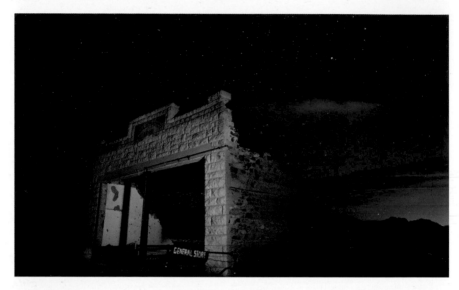

Side lighting with tungsten flashlight at f/2.0, 20 seconds, ISO 2500, 24mm lens, Canon EOS 5D Mark III.

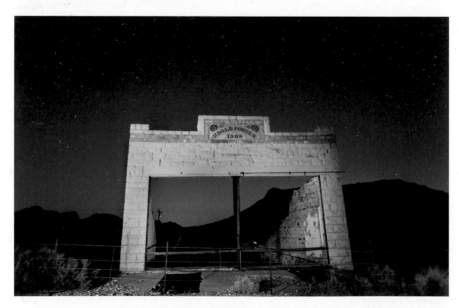

Front lighting with blue headlamp at f/2.8, 20 seconds, ISO 1600, 16–35mm II lens at 21mm, Canon EOS 5D Mark III.

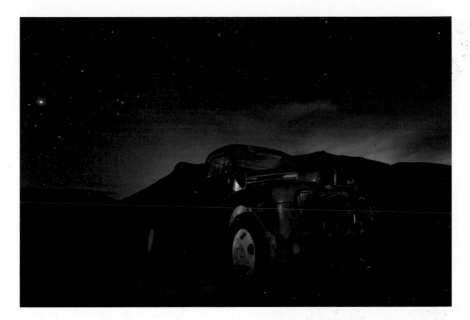

Black car at Rhyolite, Nevada. I covered a flashlight with a motion sickness bag to soften the light; it works like a softbox. A red headlamp was placed inside the car for the duration of the exposure. f/2.0, 30 seconds, ISO 1600, 24mm lens, Canon EOS 5D Mark II.

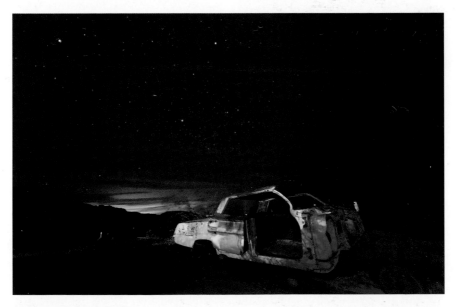

Yellow car at Rhyolite, Nevada. I light-painted with tungsten flashlight for 5 seconds on the side of the car and a red headlamp for 4 seconds on the front of the car. f/1.4, 20 seconds, ISO 3200, 24mm lens, Canon EOS 5D Mark II.

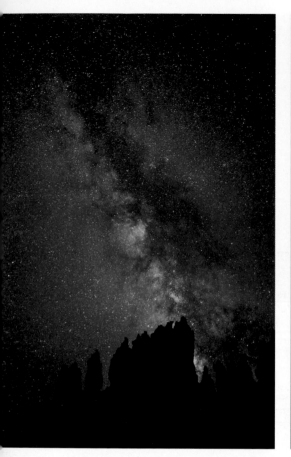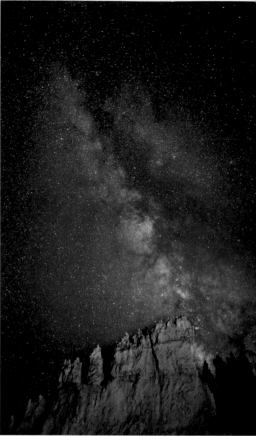

Comparison of different types of light-painting. Left: *Silhouette of the cliffs at Bryce Canyon National Park, Utah.* Right: *A blue headlamp creates a blue color cast that might look better on another subject. All images of canyon wall at f/1.8, 20 seconds, ISO 4000, 24mm lens, Canon EOS 5D Mark III.*

given aperture for the proper exposure, it will take 20 seconds from 20 feet, that is, four times the exposure. Distant objects require high-powered lights. Relatively inexpensive flood flashlights ranging from 2 to 3 million candle-power can light nearby hills.

Bouncing light off a white reflector or white card cuts the intensity of the light and broadens the coverage. The side of a building or a wall of pale rock absorbs more light than a reflector or card but spreads light evenly. Bounced light picks up the color of the reflective material. For a warm glow use a yellow reflector.

Conversely, it's easy to blow out nearby subjects. Strobe lights are too strong for direct light when photographing with a single exposure during the new moon due to the high ISO needed for the stars. If your light is too strong, cover part of the front with gaffer's tape, leaving a narrow band for the light

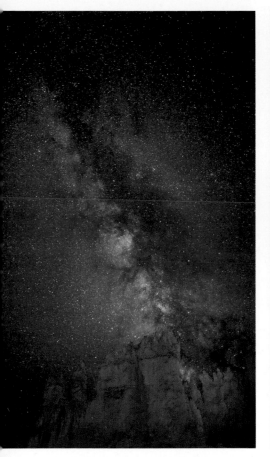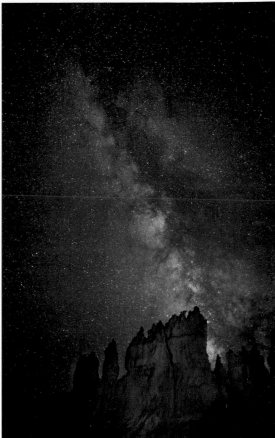

Left: *The tungsten flashlight creates a pleasing, warm tone. The front lighting is flat and not as compelling as side lighting, where the light source is to the side of the camera.* Right: *The tungsten flashlight generates more shadows when placed 10 feet from the camera on the right side.*

to come through. Adding a diffuser or two will cut more stops of light as will bouncing the light on a white card.

Don't bring your foreground up to daylight levels. Often just a hint of light is enough to set the foreground off against the background. To cover a large area with a small light, move your arm as if painting a house, smoothly and evenly. If you have a 20-second window, the norm for stars as points of light, make sure you cover all the area in that time.

VARY THE ANGLE OF LIGHT

Many photographers have a tendency to paint while standing next to the camera. Front light works fine, but other angles deliver entirely different effects. With 20 seconds at your disposal, you could move for a more interesting

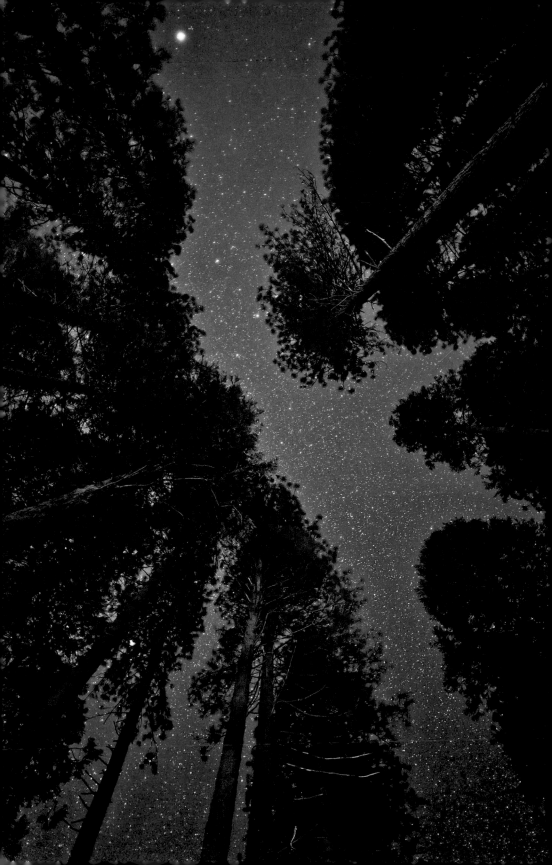

angle after starting the exposure. Sidelight enhances contrast and adds drama, giving a chiaroscuro effect that sharply delineates light and dark. Backlight creates glow and outlines subjects and provides drama. Moving around while light-painting creates different shadows for a different look.

With a little choreography, it's possible to use multiple lights in a single exposure. Station friends with different lights around the frame. You can direct attention to the most important elements in the foreground with brighter lights and define less important areas with dimmer lights. Mix colors using gels or light sources with differing color temperatures.

LIGHT PAINTING WITH STARS AS POINTS OF LIGHT

To create a complexly lit foreground while photographing stars as points of light on your own, take several exposures of the stars, paint different foreground areas yourself, and combine the images in Photoshop. For this method, take an image without light-painting as your base so the foreground is dark. Then, take another photograph and paint with one color of light in the scene. In the next exposure, choose another color or area to paint. Repeat until satisfied. The light-painting can be sloppy because you can mask out the unwanted light-painted areas later. See the next section, Combining Images.

LIGHT PAINTING WITH STAR TRAILS

If you are photographing star trails by combining several exposures (see chapter 7, Star Trails) you can paint one image in a 30-second to 4-minute exposure and then combine that image in processing. Alternatively you can paint a single-exposure star trail image. To figure out the time to light-paint a single-exposure star trail, take a 30-second exposure and see how much light you need; for example, 5 seconds of light-painting. Then when figuring out your exposure (see "Determining Exposure" in chapter 7), increase the time for light-painting in the same way you increase the time for the star trail. If you increase your exposure by seven times, then increase your light-painting by that amount as well, doubling the time with each increase. Keep in mind that large flashlights often last up to two hours.

COMBINING IMAGES

In some situations, you'll want to take two or more exposures to allow a good exposure in a foreground as well as the sky, and combine these in post-processing.

Example 1: Photograph the foreground just as it becomes visible before dawn or after sunset. At twilight, you may need to bracket the exposure (that

Opposite: *The camera pointed to the sky. The trees were light-painted by accident as a car went by and the headlights indirectly lit the trees. I prefer this subtle sidelight to fully light-painted trees. Yosemite National Park, California. f/1.4, 20 seconds, ISO 6400, 24mm fixed lens, Canon EOS 5D Mark II.*

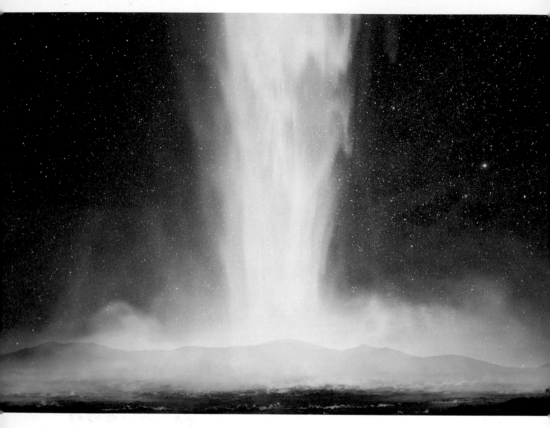

A waterfall, Seljalandsfoss in Iceland, combined with an image of the stars. The two images are layered in Photoshop with the Blend mode in the Layers panel changed to Screen. Waterfall image: f/8, 1/50 second, ISO 200, 24–70mm at 70mm, Canon EOS-1Ds Mark III. Night image: f/1.4, 20 seconds, ISO 1600, 24mm, Canon EOS 5D Mark II.

is, take several exposures one or two stops apart) to get all the detail in the scene on the landscape and take another photograph of the sky as well. When it is dark, take yet another photograph with the camera still in place and photograph the stars. You will need to refocus on the stars. This can be done in Live View, a shooting mode that lets you see on the LCD what the camera sensor sees, by focusing on a distant mountain at twilight or on a star once it gets dark. Change camera settings for photographing the stars as needed.

Example 2: Take one photograph while focusing on the foreground, at twilight if possible. If it is dark, use a flashlight to aid in focusing. This allows for a close foreground to be in good focus. If there is enough ambient light, use hyperfocal focusing at f/11 or f/16 to get the foreground to background all in good focus. See Resources. While leaving the camera in place, take another photograph focused on the stars.

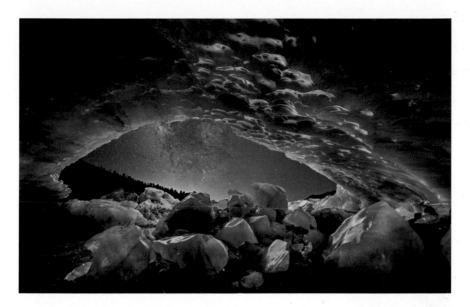

Ice cave photographed during the day; however, at night it became cloudy. The images were blended together using a layer mask (see chapter 11). Falljokull Gla-cier, Iceland. Day image: f/11, 0.5 seconds, ISO 100, 14mm lens, Canon EOS-1D X. Night image: f/1.4, 20 seconds, ISO 1600, 24mm, Canon EOS 5D Mark II.

Example 3: Combine a nighttime, star-filled sky with a landscape pho-tograph taken at dusk. Or, photograph a night cityscape. Since the glow of the city will always overpower the sky, use a night sky photograph and blend with the cityscape image. This creates an illustration, not a representation, of reality, but it shows what the city would look like if you could see through the light pollution.

To learn more about post-processing for your photographs, including combining images, see chapter 11, Post-Processing Night Images.

CONTROLLING UNWANTED LIGHT

For most of history, stars were visible on every clear night and the darkness that settled in at sunset lay mostly undisturbed the night through—no startling flashes of light from cars or pulsing lights from jets flickered across the sky. But our modern night skies are rarely unsullied by artificial light sources. Light from cities and other human endeavors offers challenges and opportuni-ties for night sky photographers.

LIGHT POLLUTION

Human energy use has made seeing and photographing the stars difficult. Persistent smog interposes a gauzy barrier, and artificial light overpowers the stars. City lights reflect off of dust, moisture, clouds, and chemicals, creating a glowing dome of light, called "sky glow." Snow reflects sky glow back to the

Loveland Pass, over an hour outside of Denver, Colorado, at around 11,990 feet, at the new moon. High elevations and the new moon in summer normally would allow a beautiful Milky Way photograph, but the city lights significantly wash out the sky. f/1.4, 20 seconds, ISO 1600, 24mm lens, Canon EOS 5D Mark II.

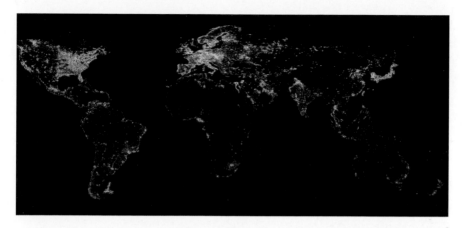

View of the world's light pollution.

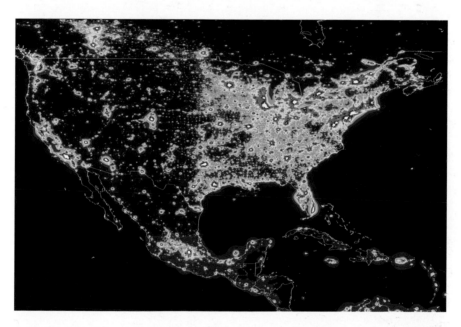

Light pollution in the United States. You can view light pollution maps at www.lightpollution.it/dmsp/. Top and bottom photos: P. Cinzano, F. Falchi (Light Pollution Science and Technology Institute, Thiene, Italy. www.istil.it), C. D. Elvidge (NOAA National Geophysical Data Center, Boulder, Colorado). © Royal Astronomical Society. Reproduced from the Monthly Notices of the RAS by permission of Blackwell Science.

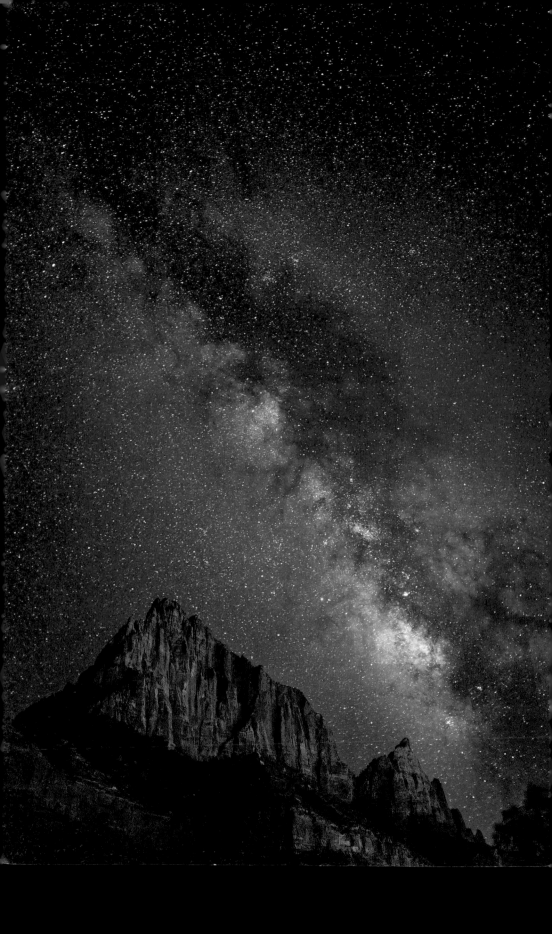

sky, and clouds act as reflectors and diffusers. The glow from major cities can be seen from hundreds of miles.

Escaping light pollution is essential for star photography. Venturing into sparsely inhabited deserts or climbing into high mountains above polluted areas helps, but the lights from distant cities and towns often illuminate the horizon like a premature dawn.

City lights cause a yellow or green glow when photographing near them. But it depends on the city and its surroundings. There is little visible glow along the coast an hour or two north of San Francisco, for example, but in the mountains an hour outside of Denver, the light scatter from the urban plains dulls the stars significantly. To find dark skies check out Dark Sky Finder at www.jshine.net/astronomy/dark_sky/.

LIGHT AMBUSHES

Try to avoid unpredictable lighting on your foreground. Car headlights are a common offender. Set up where no vehicles will drive through the composition or approach from behind to blast your foreground with its headlights. It's very likely that airplanes will streak across the sky through the middle of your image and leave trails looking like lazy meteors. Few places besides the middle of the ocean are unaffected by air traffic. To reduce the number of plane streaks, try shooting after 11 PM (1 to 3 AM tends to be better, but it varies by location). Some military bases do not allow aircraft to fly over their airspace, and those areas may have fewer planes around them. Another option is to remove them in post-processing. See Processing Star Trails in chapter 11.

Opposite: *Here, light pollution helps make the shot as ambient light illuminates the Watchman, Zion National Park, Utah. The lights from the town are well balanced enough to light the mountain yet not strong enough to overpower the stars. A larger city would provide too much light. f/1.8, 20 seconds, ISO 3200, 24mm lens, Canon EOS 5D Mark III.*

2

EQUIPMENT

Opposite: *Twilight and blue glacial river, Iceland. The slow shutter speed makes the water look silky. f/16, 1.3 seconds, ISO 640, 24–70mm II at 39mm, Canon EOS-1D X.*

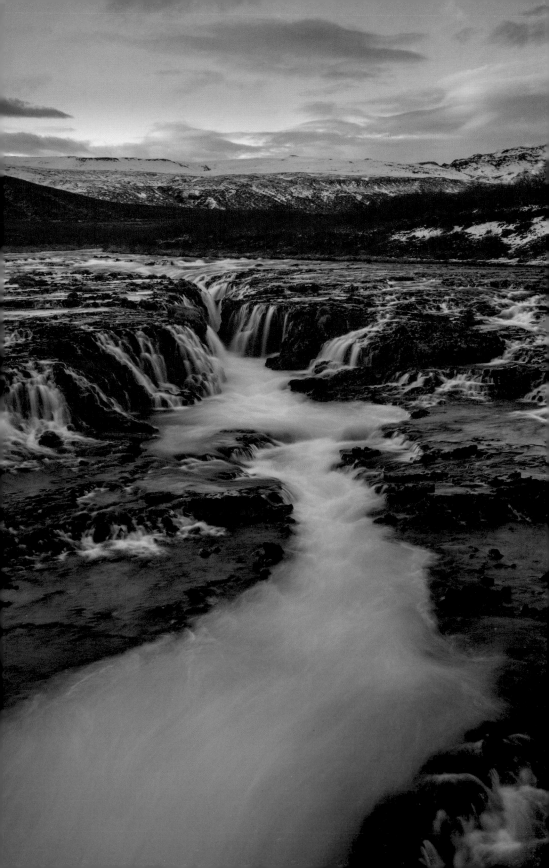

This chapter is an overview of the equipment you'll use for night sky photography. It assumes you're already familiar with DSLR cameras and their use, and that you have some experience taking photographs and processing them on your computer. Rather than reviewing basics, the focus here is on how to select and use cameras, lenses, filters, tripods, and intervalometers for the techniques particular to night sky images.

CAMERAS

Modern digital single-lens reflex (DSLR) cameras offer very high light sensitivity settings (ISO) with much less noise than in years past. Noise shows up as small, faint spots of color in the image where there should be none. Noise levels on the best digital cameras are lower than film grain at equivalent sensitivity. Smaller sensors, often with smaller photo sites (the color pixels on the sensor) packed together, produce more noise.

With recent advances in technology, including larger image sensors in DSLR cameras, we are now able to take digital photographs that have better image quality than film. The high ISO and low noise of modern digital cameras make photographing the Milky Way possible. The larger size and better resolution of sensors have increased the cost. With new models continually coming out, the latest cameras now surpass in quality the top models of just a few years ago. Point-and-shoot cameras fall short for night photography because they lack high enough ISO settings, fast and wide enough lenses, and large enough image sensors to capture an image in the 15- to 30-second window needed to stop star motion. The resulting image might look acceptable on a computer screen or the camera's LCD screen, but it will not be good enough to print. Currently, DSLRs and a few rangefinders are the smallest cameras with the ability to capture excellent images of the stars, but the advent of the first full-frame sensor, mirror-less cameras with fast lenses suggests that they will soon join the larger cameras in the night photography game.

When considering a camera purchase, focus on its ability to produce low-noise, high-ISO images instead of its megapixel count. A higher available ISO suggests better noise performance, but specs often mislead. Research the real-world performance with online reviews or, if possible, by taking a test shot with the lens cap on at a high ISO and 30-second exposure. Look at the darkest part at 100 percent on your computer screen. The faint, tiny spots are noise, and the less noise the better.

If your lens' fastest aperture is f/2.8, I recommend making sure the highest ISO is 6400 or higher. If your lens is f/4 then the images will be dark even at 6400 ISO. You can use f/4, though I don't recommend it as I prefer a lighter exposure. The image may look good on the screen but when you print it, you may find too much noise if you lighten the image for a print. Larger apertures, for example f/1.4, allow for lower ISO settings at a given shutter speed. Don't rely on the extended ISO settings found in the menus; they produce unacceptably noisy files. A full-frame camera will have wider lenses available and thus be able to use a slower shutter speed and produce less noise.

For any given camera, photographing with the fastest wide-angle lens is the surest way to reduce noise. Given identical shutter speeds, an ISO of 1600 with the lens set at f/1.4 is the equivalent to an exposure at ISO 6400 at f/2.8. (Note: In my opinion, ISO settings above 6400 are too noisy for a large print. As of this writing, I use 6400 as my highest ISO setting.) With most cameras, the difference in noise is painfully apparent. Cost and distortion are the principal downsides of the fast wide-angle lens.

CAMERAS AND NOISE

Noise is the most challenging aspect of night photography and resolution has improved fantastically in the last decade, making noise even more apparent. No one wants a dark sky half-full of stars and half-full of computer generated flecks.

All things being equal, higher ISO speeds typically generate more noise than lower ones. The camera electronically boosts sensitivity for higher ISO, producing spurious signals that appear as noise, increasing with each increment of boost. We see two types of noise, luminance and chromatic. Luminance noise is gray and resembles film grain and is easier to tame with software. Chroma noise looks like colored speckles. A digital sensor "sees" light differently than a human being or a strip of film. If we examine a 12-bit capture that records 4096 tonal values from pure black to pure white, we'll find those values are not evenly distributed. The brightest f-stop contains half of all the tones, 2048. The next brightest contains half of the remaining tonal values and so on down to the darkest stop, which is left with only 128 tonal gradations. (See the Tonal Values by Exposure chart in the "Histograms" sidebar in chapter 5.) With so little information in the darkest stop, the noise produced by the electrical charge on the sensor isn't masked by tonal information. With a digital image, more tonal values equal more signal, masking the noise. The noise remains but is more difficult to discern. In summary, the darkest stops contain the least amount of information and the most amount of noise.

Also keep in mind very long shutter speeds add noise as well, with the blue channel generating more noise than the red and green channels. The darkest stop always appears the noisiest, a consequence of sensor physics and the contrast of bright noise against a dark background.

Some cameras may have amp glow, a magenta or red glow in the corners of the images that occurs with long exposures and comes from the sensor creating its own light. Try turning on long exposure noise reduction to help with this, but review your image to verify that it does. If needed, darken the areas with amp glow in post-processing.

NOISE REDUCTION FEATURES

Some cameras feature in-camera noise reduction, helpful for long exposures. Two of the most common are long exposure noise reduction, which compares a completely dark image to an exposed image to extract the noise, and high ISO noise reduction, which suppresses noise but softens the image. Check the custom camera settings menu for your camera to enable or disable these

features. Whether you use long exposure noise reduction or high ISO noise reduction out in the field, all night shots benefit from noise reduction techniques applied when you process the images on your computer.

Long Exposure Noise Reduction

Long exposure noise reduction (LENR) works by taking a second exposure while blocking all light. It is like taking a second exposure with the lens cap on the lens. This second exposure is called a dark frame. The camera compares the dark frame, which contains only noise, to the original image. Software recognizes noise in the dark frame and extracts similar noise from the original. With the in-camera noise reduction feature turned on, the time it takes to get a photograph doubles. A 20-second exposure is followed by the 20-second dark frame exposure, plus some processing time.

Because of this second exposure, in-camera noise reduction leaves gaps that ruin time-lapse and that will show up in the final image when using multiple images to stack together for star trails. LENR works best with star trails made with a single long exposure. Turn it off for stacked star trails. Some cameras default to an auto noise reduction setting; be aware that it might come on when you don't want it.

SHOOTING WITH JENNIFER

I don't notice much noise reduction with the long exposure noise reduction turned on for 20-second exposures. It removes a few hot pixels and some colored dots, but doesn't help with the rest of the noise. In tests from 1 second to 32 minutes with several Canon cameras, I found that it helped after exposures of several minutes. I don't use noise reduction on anything less than 4 minutes, but I always use it with single exposure star trails at 4 minutes or higher. You can test your own camera by leaving the lens cap on and taking long exposures at different time increments at 3200 ISO or, better, at 6400. Look at the results on the computer, viewing them side by side at 100 percent view.

For star trails with a single exposure, turn on long exposure noise reduction. After capturing the image, say for a 1-hour exposure, it will immediately close the shutter and record a black image for 1 hour, disabling the camera. You can pack up the camera (Don't turn it off!) and head back to camp or civilization while the camera processes the long exposure noise reduction. Long exposure noise reduction begins with a click of the camera, and a red light on the back of the camera flicks on. Because the mirror doesn't move out of the way during the dark frame recording, you can look though the viewfinder, which lets you know when you can move the camera. The capture is complete when the red light goes off.

Don't warm the camera while it processes the dark frame. Different temperatures produce differing noise signatures on the sensor, which will confuse the processing.

High ISO Noise Reduction

Many cameras include a second form of noise reduction, high ISO noise reduction. This applies only to JPEG captures, not RAW, unless you are using the camera manufacturer's software. Unlike noise reduction for long exposures, this feature behaves like software found in Photoshop's Adobe Camera RAW, Lightroom, or Nik's Dfine 2.0 that softens the images as it suppresses noise. If you use this feature in your camera, these computer-based programs ignore the remaining lower contrast noise, resulting in higher noise levels in your images. Since the computer programs work better than the in-camera versions, disable high ISO noise reduction on your camera and clean up the image in your photo editor instead. If you are unsure how to reduce noise with software, photograph both a JPEG and a RAW version. The JPEG will yield an acceptable image, and you will have a RAW in the archive if you wish to go back to process it later for a higher quality result.

LENSES

When choosing a lens for night photography, consider the focal length for your compositions, as well as the quality and attributes of the lens. The focal length of the lens you use will affect your options for composition of the foreground and the Milky Way. In general, lenses with wider angles of view work better for photographing stars as points of light. A wider angle includes more of the sky and minimizes the movement of stars. A telephoto lens captures a small portion of the sky. However, a telephoto magnifies the movement of the stars, requiring faster shutter speeds to stop motion.

When it comes to resolution and impact, lenses are equal partners with image sensors and software. Judge the quality of a lens based on aperture, resolution, distortion, and focal length. Above all, look at the images it produces. Lenses vary in contrast, color, and sharpness. You may prefer the brightness or luminescence (glow) of a particular lens or its snap, the way it separates an object from its surroundings.

APERTURE

The aperture of a lens refers to the diameter of the iris in the lens that controls the amount of light hitting the sensor for any shutter speed. The size of the aperture is called an f-stop. The f-stop number is a ratio of focal length to aperture diameter. Thus f/2.8 means the diameter of the aperture is 1/2.8 of focal length. Additionally, the wider the lens, the larger the maximum possible diameter of its aperture. Smaller f-numbers correlate with a larger aperture opening, letting in more light per unit of time. Aperatures from widest to narrowest a full stop apart are: f/1.4, f/2, f/2.8, f/4, f/5.6, f/8, f/11, f/16, and f/22. Most cameras offer one-half- or one-third-stop increments between full stops.

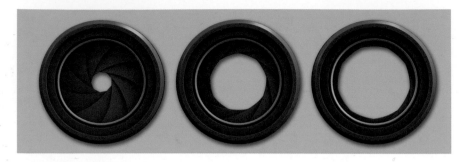

Aperture is controlled by opening and closing the iris. Smaller apertures require more time to produce the same exposure as a wider aperture.

The term "wide-open aperture" refers to the lowest number (for example, 2.8), which is the widest diameter available. The phrase "opening up" means making the aperture wider and moving to a smaller number, such as f/2.8 to f/2.0, while "stopping down" refers to setting a smaller aperture and a larger number, such as going from f/11 to f/16. Smaller aperatures require more time to produce the same exposure as a wider aperature.

The smaller the f-stop number, the wider the depth of field (the depth of sharpness), and the larger the f-stop number, the shallower the depth of field. Generally f/5.6 or f/8 are the sharpest f-stops, and they are in the middle range for depth of field on the lens. They reveal the largest number of stars in the image.

Since wider aperture lenses, such as f/2.8, let in more light, these lenses shot wide open produce less noise because lower, cleaner ISO settings are possible for any given shutter speed. A wider aperture is better for stars as points of light. In fact, any wide-angle f/2.8 lens works great for stars as points of light. But there is a trade-off in using the wider apertures because wider apertures lead to increased distortions.

ANGLE OF VIEW

Each lens has a given angle of view for a given sensor size. Full-frame sensors allow for a wider angle of view and greater focal length on a given lens. Focal length acts like a magnification factor. The angles given below refer to a full-size sensor, the size of 35mm film. To calculate the angle of view on a crop-sensor camera, multiply the focal length of the lens by the crop. Thus, a 50mm lens on a 1.5 crop sensor has the same angle of view as a 75mm lens on a full-size sensor: 50mm x 1.5 = 75.

To easily determine the angle of view for your crop-sensor camera and lens, check out the online calculator at www.sweeting.org/mark/lenses/canon.php.

FOCAL LENGTH

The focal length of the lens impacts composition of the image. Look at the coverage area of the Milky Way and the foreground in the following four images for examples of the effects of different focal lengths.

Mount Rainier National Park, Washington. The trees tilted by the barrel distortion add to the composition as they point to the sky. Notice the angle of the Milky Way as a diagonal line, photographed in July. f/1.4, 20 seconds, ISO 1600, 24mm lens, Canon EOS 5D Mark II.

Wide Angle. Wide-angle lenses, including fisheye lenses, are favored for most star photography because they allow room for an interesting foreground, a large display of stars, and better exposure.

Fisheye and wide-angle lenses distort straight lines. The center seems to bulge out, so lines are curved and more noticeable as you get farther from the center of the frame, an effect called "barrel distortion." It is more pronounced in fisheye lenses with 180-degree views and less prominent with rectilinear wide-angles. A fisheye lens is designed to have the strong curvature. The distortion is not obvious when the camera is parallel to the ground, but when the camera is pointed up to photograph the sky, the horizon line curves sharply. In some cases a curving skyline or tilted trees strengthen a composition.

Normal. On a full-frame camera, a 50mm lens is considered normal, neither telephoto nor wide angle. It's possible to get a fast normal lens at a fraction of the cost of the wide-angle or telephoto lens. A 50mm lens has an angle of

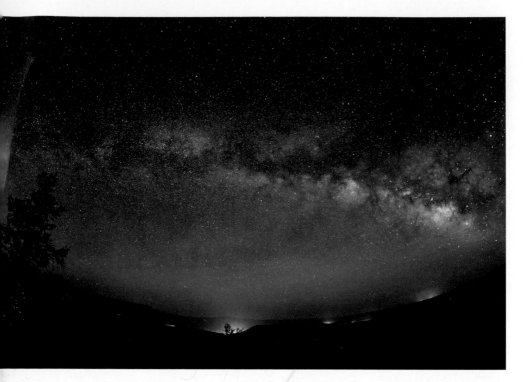

The fisheye lens provides a wide area of view of the landscape. Photographed at Bryce Canyon, Utah, in June, this image shows the expanse of the Milky Way. Notice the curvature of the lens on the horizon line. f/2.8, 25 seconds, ISO 6400, 15mm fisheye, Canon EOS 5D Mark III.

view of 45 degrees, good for twilight and star trails, but I don't recommend it as a first choice for stars as points of light at a new moon due to the high ISO needed and fast shutter speed.

Telephoto. Telephoto lenses are great for a number of applications. They can capture a giant moon rising above the horizon or create straight star trails because the angle of view is so narrow that their curvature is not evident. Few very long telephotos are fast. The professional and pricey 500mm to 600mm lenses are only f/4, three stops away from the fast wide angles. Slower telephotos can require boosting ISO at the cost of additional noise. The 200mm lens has an angle of view of about 10 degrees while a 500mm looks at only 4 degrees of arc.

14mm f/2.8 and 14–24mm f/2.8. This wide coverage area, a 114-degree angle of view, is superb for photographing stars. It is a great choice for circular star trails or when you want to cover a large portion of the sky or Milky Way. If you point the lens up instead of toward the horizon, vertical lines will show some barrel distortion. The curvature may work in the composition. If not, lens correction software can straighten the lines while cropping out some of the

original image with some loss of resolution. A benefit of a 14mm or 15mm lens is that the shutter speed to stop the stars as points of light is 30 seconds, allowing for a reduced ISO setting of one-third f-stop.

15mm f/2.8 and 16mm f/2.8D fisheye. Although the 15mm and 16mm fisheye lenses have a slightly longer focal length, their strongly curved lenses deliver a wider angle of view than the 14mm—a full 180 degrees. The 16mm fisheye also delivers a full 180 degrees with a full size sensor (and 107 degrees with the FX crop sensor). This lens is fun to photograph with as it magnifies the barrel distortion, bending the periphery more strongly and delivering a fun-house mirror effect. It can capture the arc of the Milky Way from horizon to horizon in June, July, and August.

8mm and 8–15mm f/4 fisheye (Canon). This ultra-wide zoom has the same maximum angle of view on a full-frame sensor—180 degrees—as the 15mm fisheye and it provides the same angle of view on a crop sensor. An 8mm on the full-sensor camera renders the image as a circle bounded by black.

The 8mm fisheye lens produces a circular boundary on a full-size sensor. Zion National Park, Utah. f/4, 25 seconds, ISO 6400, 8–15mm fisheye set to 8mm, Canon EOS 5D Mark III.

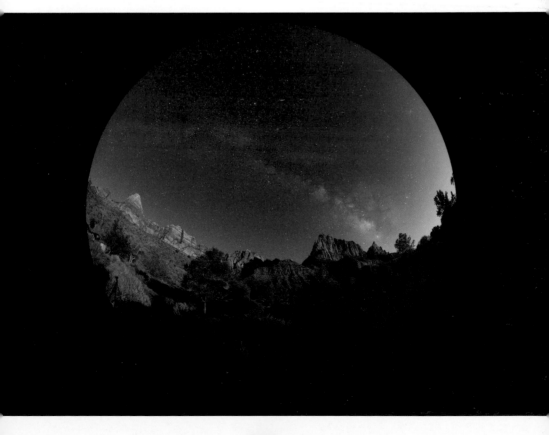

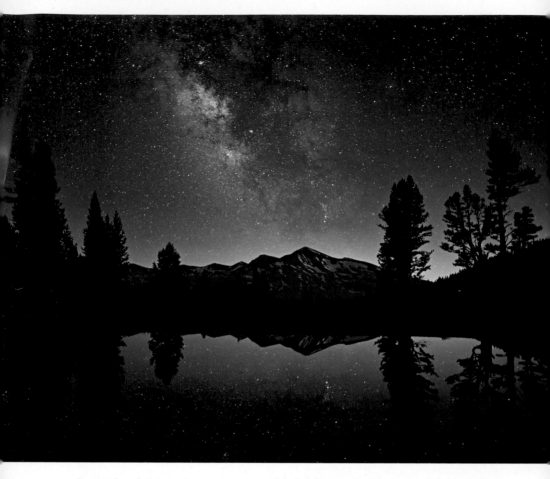

Example of 24mm lens coverage of a landscape in Yosemite National Park, California. f/1.4, 20 seconds, ISO 2000, 24mm lens, Canon EOS 5D Mark II.

The Canon 8–15mm widest aperture is f/4, so it requires a longer exposure, but because of the wide angle of view, doubling the exposure will not appear to increase the movement of the stars; 30 seconds works well.

16–35mm f/2.8. Used at its widest focal length, this is an excellent choice for circular star trails and photographing the Milky Way with stars as points of light. The angle of view ranges from 108 to 63 degrees. The benefit of this lens is the flexibility to use between 16mm and 35mm when defining your composition.

24–70mm f/2.8 and 24mm f/1.4. The 24mm f/1.4 may be the best lens for photographing stars as points of light. At two stops faster than f/2.8 lenses, it can stop the motion of the stars at much lower ISO settings. If an f/2.8 lens needs an ISO of 6400 or more to stop the stars for a 20-second exposure, an f/1.4 lens can capture the same image with an ISO of 3200, which generates

significantly less noise. With its 84-degree angle of view, a 24mm focal length can capture a large portion of the sky. It also doesn't shrink the foreground and background as much as wider lenses. Even at f/2.8, a 24mm lens often produces an ideal balance between foreground and stars. The 24–70mm at f/2.8 is ideal for stars as points of light or star trails. My favorite focal length for landscapes by day or night is 24mm, and you may notice I use it often.

35mm f/1.4. Like the 24mm fixed lens, this lens is fast at f/1.4, making it a great choice for the stars. With a narrower angle of view than other wide-angle lens, it shows less of the band of the Milky Way but gets in tighter on the dense area with gasses and closer to the foreground elements.

70–200mm f/2.8. Like the 24–70mm lens and 24mm f/1.4, these f/2.8 lenses work well for star trails and stars as diagonal lines through the scene.

RESOLUTION

Resolution refers to the amount of detail a lens can resolve, but it doesn't account for the quality of the detail. Resolution degrades as objects become finer, that is, from the thickness of a pin down to a human hair.

Resolution varies with aperture. Most lenses get sharper as the aperture gets smaller and then sharpness falls off at the smallest aperture due to diffraction effects. A series of identical pictures of a scene full of detail shot at each aperture is an easy and certain way to establish the sharpest aperture for a given lens. Generally the middle ranges, often f/5.6 or f/8, are the sharpest f-stops on the lens and reveal the largest number of stars in the image.

VIGNETTING

Vignetting is the darkening of the corners and edges of the frame that happens at wide apertures such as f/1.4. The effect is reduced toward f/5.6. Test your lenses by photographing at different apertures to see the effect.

DISTORTION

Distortion comes in many forms. It may bend straight lines, transform circles into blobs, or produce color anomalies at sharp edges. As light travels through the lens it can generate effects like barrel distortion, coma, and chromatic aberrations. These effects can be controlled, or enhanced, through your choice of lens and f-stops, or in post-processing with software.

Barrel Distortion

Wide-angle lenses exhibit "barrel distortion," in which parallel lines appear to bulge from the center of the lens. If you place the horizon at the bottom of the frame, for example, you'll see either side of the horizon line curve upward, a consequence of the curved front element. The wider the angle, the worse it is. Fisheyes exaggerate this curvature the most, but that is the purpose of this lens. These curves can be corrected in Photoshop and other programs, but the process crops out some of the image and pixel peepers may detect less resolution along the sides.

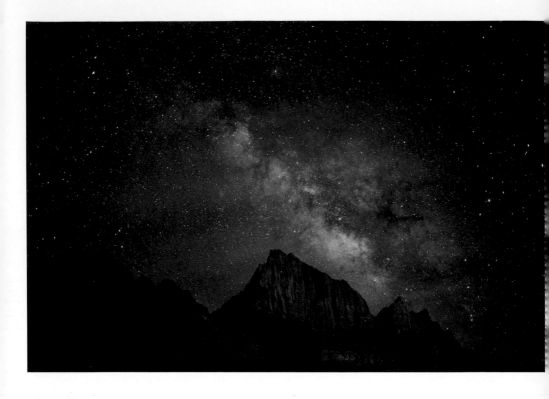

Vignetting. Notice the difference in the darkening of the corners and edges of the frame in these three images. The image above has the most darkening at f/1.4 and the image opposite top is at f/2.0 with less darkening. The bottom image is at f/4.0 and has little darkening. At 5.6, not shown, darkening goes away completely, but the level of noise is too strong for a good print at such high ISO settings.

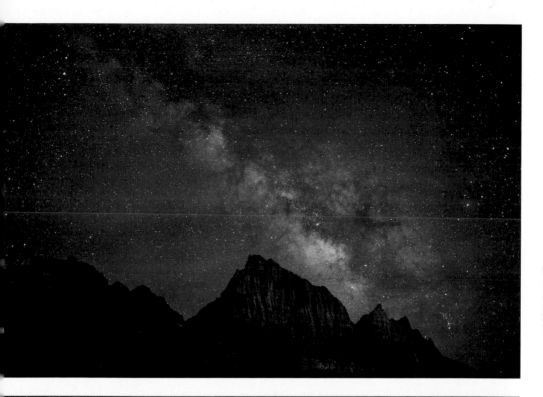

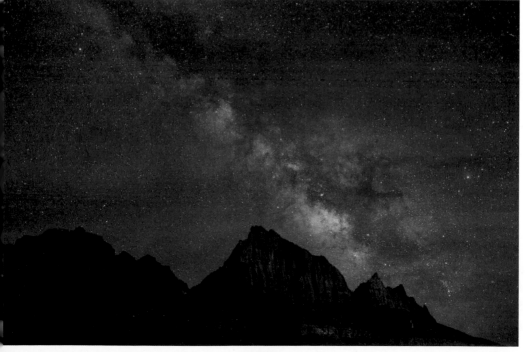

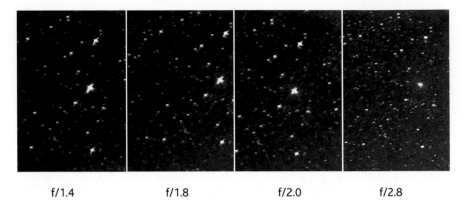

| f/1.4 | f/1.8 | f/2.0 | f/2.8 |

Coma at f/1.4, f/1.8, f/2.0, f/2.8. Notice the wings and tails on the stars and how that effect decreases with the larger f-stop number. Distortions disappear at f/5.6, not shown.

Coma

Coma occurs when light rays farthest away from the center of a lens do not come to focus on an identical image plane, the camera sensor. Stars near the outer edge of the frame, especially the corners, will display wings and comet-like tails trending away from the optical center. This occurs more often with wide-angle lenses because of the curvature of the frontal element. Coma has different effects on different lenses. A 14mm lens tends to have more coma than the 24mm lens. In addition, the aperture affects how much coma we see in the images. Take a look at these examples of coma at different apertures and focal lengths.

Chromatic Aberration

Chromatic aberration occurs when different wavelengths of light (colors) pass through a lens, but the lens does not focus them at the same point. It looks like a color halo or fringe around the stars, often cyan or red. It can be seen on the edge of a subject where dark and light areas meet. Chromatic aberration can be corrected in post-processing, but the quality of lenses you use and the f-stop will also make a difference.

Correcting Distortions

To minimize coma and aberrations, make sure focus is spot on, employ chromatic aberration correction in post-processing, and stop down toward the middle apertures as much as possible. The additional depth of field produced by stopping down one stop focuses the different color focal lengths more accurately. Stopping down the lens, for example from f/2.8 to f/4, reduces coma and chromatic aberrations significantly. However, stopping down increases noise, because you need to double the ISO for each stop. You must balance benefits against costs.

Coma and chromatic aberration effects on different lenses, here viewed from the corner of the lens where it is most prominent. The centers of the images do not have significant coma or chromatic aberrations.

For consistency in testing the lenses, the same settings were used at f/2.8, 20 seconds, ISO 6400, Canon 5D Mark III. The images do not have chromatic aberration turned on or vignetting removal applied in processing in order to show the distortion effects.

24mm fixed: The least amount of coma.

15mm: Significant coma in the corners.

14mm v. II: In the corners of the frame, the stars are more like lines, but they are points of light elsewhere.

16-35mm II: Significant coma in the corners.

SHOOTING WITH JENNIFER

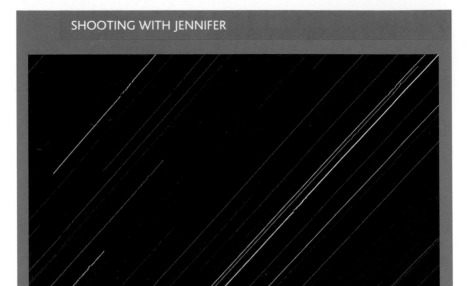

An intervalometer helps you capture star trails with ease, but only in the right conditions. The vibration caused by wind creates uneven lines in star trails, as shown here, so I don't recommend shooting star trails on windy nights.

I have ruined intervalometers and cable releases by not using and storing them properly. The ends soon fray at the connection points to the camera and to the intervalometer controls. To prevent this, I tape the cord with black electrical tape, to reduce the length of the cord so it doesn't hang to the ground from the camera. Then I tape the ends. Next, I affix Velcro to the tripod and on the intervalometer or cable release, and then stick the intervalometer to the tripod. It's dorky but saves me having to buy a new one.

The use of prime lenses, which have a fixed focal length (versus zoom lenses), also produces fewer distortions. The greater number of lens elements in a zoom lens tends to produce more aberrations. Higher quality and higher priced prime lenses generate the least coma, chromatic aberrations, and barrel distortions at each f-stop.

FILTERS

Remove any filters on the lens when photographing at night, including UV or haze filters. Filters are both unnecessary and unhelpful. UV filters cause concentric rings in auroras. Polarizers block one stop of light, which requires

doubling the ISO to compensate. Color correction filters are passé since the advent of color temperature settings in digital cameras. Finally, any filter can cause diffraction effects.

TRIPODS

A sturdy tripod is a must. Vibration from the camera and wind will ruin longer or multiple exposures. When photographing outdoors, even a gentle breeze can shake the camera, introducing blur into the photograph. A flimsy tripod transmits movement and produces a poor result; a heavier tripod equipped with a heavy head provides more reliable results. It's very important to keep all the knobs and screws well tightened. Many people don't lock down the turning base, but with a long 20-second exposure, a breeze can excite vibrations in any untightened part of the tripod or head. If the added weight or extra expense of a heavy rig is too much, add mass to your tripod system by hanging your camera pack or a sack full of rocks from the center post. Make sure there is no wiggle room at any of the joints where the tripod head meets the tripod.

INTERVALOMETERS

An intervalometer takes the drudgery out of photographing star trails. It acts as a cable release, self-timer, interval timer, long-exposure timer, and exposure-counter. Without it, you may need to stand next to the camera taking shot after shot, counting the seconds for each exposure. Since it can take a certain number of images at specific intervals, it is a tremendous convenience when photographing a series of 4-minute star trail exposures. Most cameras limit themselves to 30 seconds or less for the exposure time. Some Nikon cameras have a built-in intervalometer, but there are some restrictions to the time or number of images it will take. For cameras without a built-in intervalometer, not all models have a port for an intervalometer or use the standard port. Check compatibility with your camera before purchasing. If your camera has nonstandard ports, you can use third-party intervalometers such as Promote Control, or the iPhone Triggertrap app.

3

PREPARING TO SHOOT

Opposite: *A twilight shot of sea stacks allows for a long exposure and a misty looking ocean, Bodega Bay, California. f/10, 15 seconds, ISO 100, 24–70mm at 28mm, Canon EOS-1Ds Mark III.*

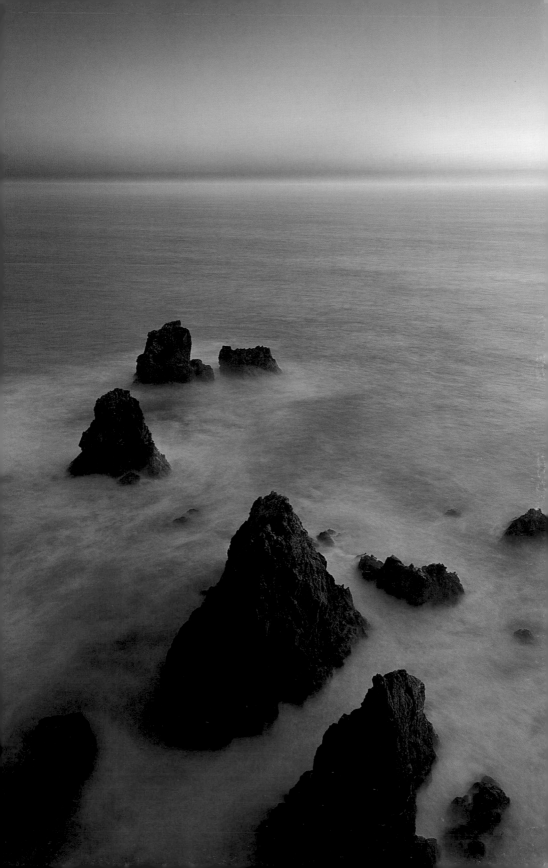

Night sky photography necessarily involves long hours outdoors in the dark. Being prepared will not only help you get shots you love but also help you save time and keep frustrations to a minimum. This chapter has two main branches: mental planning and logistical preparations. Planning out your shots in your mind and researching ahead of time what will be in the sky when you go out allow you to capture the celestial events that most intrigue you, and perhaps a few unexpected images as well. Preparing for the logistics of your shoot will ensure you have the equipment you need and help you stay out long enough to capture the images.

PRELIMINARY RESEARCH

Before the shoot, you'll want to find out where the moon and Milky Way will be in the sky. Apps like Star Walk and Heavens Above, the website www.astronomy.org, and Stellarium, a free desktop planetarium, will show you where in the sky you can see the Milky Way or the moon. See the Resources section at the end of the book for more good sources of information. If your aim is to capture less predictable night sky events—meteors, iridium flares, and auroras—you'll find that planning and research can still pay off. The National Oceanic and Atmospheric Administration (NOAA) and other agencies publish much of their space weather forecasting data on their websites. Space weather refers to the conditions in space, especially conditions near the earth. While meteors and auroras cannot be pinpointed with absolute certainty, you can increase your chances of capturing these ephemeral night sky events if you research forecasts before you head out into the field.

Finally, one last tip: scout in the daylight and decide what you will photograph—stars as points of light, star trails, the moon, or another celestial phenomenon.

PHOTOGRAPHING THE MILKY WAY GALAXY

As our planet orbits the sun, the brightness of the sun blocks our view of most of the galaxy. The galactic center of the Milky Way, where the stars are most densely clustered, is near Sagittarius, which looks vaguely like a teapot. If we wish to photograph Sagittarius in July, it will be midway through its transit across the night sky at midnight. In January, it will be directly behind the sun, and daylight will overpower it until April, when our orbit returns the wider part of it to the night.

When we look at the stars in January, we look toward the outer edges of the galaxy. Sagittarius is the southernmost constellation. From North America, it seems to glide just above the horizon from east to west, but in the Southern Hemisphere it wheels directly above. As a consequence, each night the constellation is visible longer in the Southern Hemisphere than in the Northern. However, for a photographer, lower may be better, allowing us to place the luminous center of the Milky Way above an interesting foreground.

The best months to see the bright center of the Milky Way are June, July, and August. But keep in mind that Sagittarius appears at different times of day: It first appears just before dawn in the south to southeast in early April, but is quickly obliterated by the rising sun. In May, you'll have to get up hours before dawn to catch the show, but by July, the constellation will be as high in the sky as it will ever get. Conditions are ideal in August when it's still well above the horizon and visible earlier in the evening. By mid-September, we see less of the constellation and for less time until it sets for good in early October, sliding below the horizon before sunset.

The Milky Way appears in the sky in different positions depending on the time of the night and the month. Late evening in April and May, or early evening in June, are good times to photograph the Milky Way as a band across the sky. Look for a strong diagonal line in July and August. A more vertical band can be seen during some times of night while the Milky Way is in transit in July and August.

In the Northern Hemisphere, in the summer months around July, you may notice the Milky Way move across the sky clockwise from the south to southwest. In the Southern Hemisphere, the Milky Way moves counterclockwise from the south to southwest.

In the contiguous United States, wait about an hour and a half to two hours after sunset to get the really dark skies. You will need to wait longer the closer you are to the North Pole since twilight lasts longer in places such as Alaska and Scandinavian countries.

FINDING YOUR LOCATION AND CLEAR SKIES

Several factors contribute to seeing plenty of stars. A dark, cloudless night with low light pollution is not enough. You will see more stars when the air is clean—without smog and with little wind to stir up dust. Ocean shorelines often enjoy low air pollution. Mountain and desert air is excellent for shooting stars because the low humidity allows for the stars to shine through. When researching your locations, consider deserts, oceans, high mountain peaks, and areas of low air and light pollution.

Overcast days and clouds can block the stars, so choosing a clear night is important. On the other hand, clouds can add interest to the sky when we can still see stars as well. When there is a thin layer of haze in the sky, it looks dull and the stars are blurry. The haze acts as a soft-focus filter. You will see a white halo around the stars even though the stars are in focus, which creates an unusual effect: the stars look bigger. Some people enjoy this, though sharp stars are preferred for prints. To photograph clouds moving at twilight, try a 2-minute exposure, or longer, to get the motion of the clouds at dusk for a wispy effect.

Check the weather for wind and rain. For clouds, go to 7timer (7timer .y234.cn); click on "weather" and "total cloud cover." Clear Sky Chart (cleardarksky.com/csk/) is an astronomer's forecast that shows the next 48 hours of cloud cover for North America.

Clouds are colorful even well after sunset. Death Valley National Park, California. f/1.8, 8 seconds, ISO 640, 24mm II lens, Canon EOS 5D Mark II.

TIP Observatories or locations for sky parties, where people gather to view the sky in dark locations, are good places for photographing stars. Be careful to use only red lights and avoid driving into the area with your headlights on, or others will be annoyed.

FIELD CONDITIONS

Night sky photography entails working in darkness and often in cold conditions. You'll avoid grief by setting up your gear before the sun goes down. Likewise, running down a checklist will save you from suffering through a dead battery midway through a star-trail sequence, discovering you left your ISO at 25,600, or lamenting the hat left behind on an icy evening.

WORKING IN THE DARK

Know your camera blindfolded. When photographing in the dark, pausing to find the correct button to change ISO or color temperature is a waste of time.

Practice changing your settings without looking at the camera. A few minutes of practice over the course of a few days will establish the memory.

Use a red light. When you must see something in the midst of a night photograph, the white light of a headlamp or flashlight will obliterate your night vision. It can take 30 minutes or longer for it to return.

A low-intensity red light, such as the red LEDs found in some headlamps, minimizes night vision loss. Red LEDs can also serve as "brushes" for light-painting.

> **TIP**
>
> Place a piece of black electrical tape over the red or green light that shows when the camera is in operation. This light can be annoying and seem very bright on a dark night.

PHOTOGRAPHING IN THE COLD

The cold plays havoc with batteries, lenses, and tripods. When the mercury falls below freezing, a battery may run out of juice after just a few frames. Time-lapse and star-trail photography become impossible. Lenses collect dew, which ruins images. Carbon fiber tripods become brittle and can crack if banged or dropped when cold. A few simple measures can protect you and your equipment against the cold.

BATTERY LIFE

Heat and insulate the camera to preserve the battery. On extremely cold nights, place a chemical toe warmer (available at outdoor clothing stores) around the battery area of the camera. The toe warmer has a sticker on the back to hold it in place. You can also use chemical hand warmers and keep them in place with a Velcro wrap, a rubber band, or tape. On very cold nights, insulate your intervalometer as well. Its tiny battery will give out quickly. Dew heaters are heating strips that can be placed on the camera and lens but they require a 12-volt battery pack, so they are not as easy to use.

Bring extra batteries. Fully charged batteries are very important if it is cold or you are photographing star trails. Batteries slow down in the cold but will work again when warmed up. Keep spare ones in your pocket with hand warmers.

A supplementary battery pack can double the battery power you have available. The pack operates with AA or rechargeable camera batteries. If attached as a handgrip at the bottom of the camera, the pack often includes features for using the camera in a vertical orientation, such as shutter and exposure controls.

FROST AND CONDENSATION

Extreme cold can surprise you, freezing mechanical cable releases or sealing your water bottle shut in moments. Expect dew or frost buildup on the front element of your lens in below-freezing temperatures. If you are photographing and you find that an image that was previously sharp is out of focus, first

check the front element of the lens for buildup. To prevent this, you can wrap the lens with a chemical toe or hand warmer and an insulating cover. A lens hood helps to forestall frost too. A lens wrap can also be useful; it keeps the frost off the front element of the lens. While shooting, pause the sequence from time to time and either look at your LCD or check the front element with your red flashlight to make sure there's no buildup. Be careful not to bump the camera. A chamois or another cloth such as a small, super-absorbent pack towel will efficiently wipe the dew or frost off the lens. These work better than a lens cloth, which just smears the water.

Don't bring your camera directly from the cold into a warm room. Condensation can be a major problem. The sudden change in temperature can cause fogging of the lens and camera that can last for many hours, making the lens temporarily unusable. Try putting the camera in a resealable food storage bag or keeping your camera zipped up in the camera bag. I take out my compact flash cards before I go inside, so I don't have to open my camera bag. Silica gel desiccant packs placed in your camera bag or with the lens can be used to help with condensation as well.

Consider getting tripod leg wraps or foam pads to protect your hands from the cold when you pick up your tripod. You can buy them or make them yourself with some closed-cell foam. Be careful with carbon fiber tripods as they become susceptible to cracking on impact in cold weather.

COLD-WEATHER CLOTHING

Finally, protect yourself. Bring warmer clothes than you expect to need. It's easy to get chilled while inactive. Wear a hat. The head doesn't radiate more heat than any other part of the body, but if it's exposed while the rest of the body is covered, half of the heat loss will radiate from the head. Many photographers swear by photographer's fingerless gloves, which leave the fingertips exposed, but other people prefer fingerless mitts. You can operate the camera with complete freedom and your fingers regain warmth quickly because they are in contact with each other inside the mitt. It's a snap to pull the mitt over your fingers when they get cold. Thin liner gloves under the fingerless mitts add additional warmth. Photographer's gloves allow just the forefinger and thumb to be exposed to the elements.

Thick-soled, insulated boots keep feet warm when standing in snow or ice. To prevent slipping on ice, spikes can be used to cover the sole of insulated boots. When it's cold enough to form frost on the windshield while photographing, put a windshield sun block or cardboard on the outside of the windshield so you don't have to scrape off the ice.

CHECKLIST: BEFORE YOU SHOOT

There's nothing more frustrating than fumbling in the dark to change camera settings or replace a dead battery. Arrive prepared.

WHAT TO BRING:
- ❏ Camera, lenses, lens hood
- ❏ Plenty of formatted memory cards
- ❏ Sturdy tripod and ball head
- ❏ Battery grip and plate to attach to ball head or L-brackets for battery grips (optional for star trails)
- ❏ Extra batteries
- ❏ Cable or shutter release (or use self-timer)
- ❏ Intervalometer
- ❏ Headlamp with red light
- ❏ Flashlight and gels for light-painting; diffusion material
- ❏ Extra flashlight bulbs
- ❏ 4x power loupe
- ❏ Sensor cleaning tools
- ❏ Chamois and cloth to wipe frost and condensation off the lens
- ❏ Warm clothing: heavy down coat, wool or fleece sweater, long underwear for both top and bottom, hat, and warm boots
- ❏ Photographer's mitts or gloves and liner gloves
- ❏ Rubber bands or velcro to attach hand warmers
- ❏ Hand and toe warmers for hands, toes, camera, lenses, and pockets
- ❏ Bug spray, if needed
- ❏ Food and water
- ❏ Windshield sun block or cardboard for the outside of the windshield to prevent frost
- ❏ Compass

WHAT TO PREP:
- ❏ Charge batteries, in the camera and backups.
- ❏ Place black tape on the red or green processing light on your camera.
- ❏ Clean the sensor.
- ❏ Clean the lenses.
- ❏ Remove filters.
- ❏ Put on lens hood to prevent flare and frost buildup.

4

FOCUS

Opposite: *Meteor and the Milky Way over Lake Tahoe, Nevada.*
f/1.4, 20 seconds, ISO 3200, 24mm, Canon EOS-1D X.

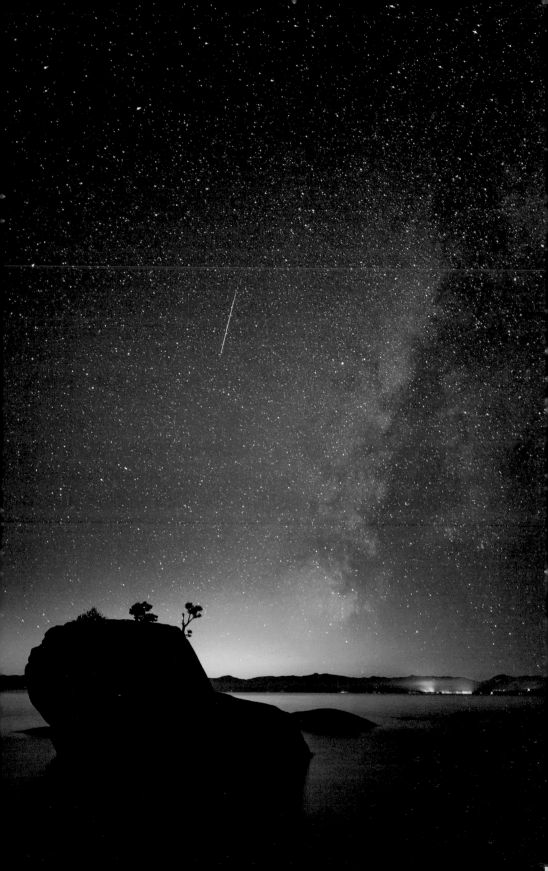

A chieving sharp focus on the stars through the viewfinder is almost impossible, especially with a wide-angle lens. The stars appear very small, and the difference between nailing the focus and missing it is very slight. You can autofocus on the moon or a distant object, manually focus with the aid of the LCD, or use trial and error.

AUTOFOCUS

The easiest way to focus on the stars is to use autofocus on the moon. It easily locks on such a bright object, even the thinnest crescent of the new moon. After focusing, change focus to manual so autofocus doesn't engage at the wrong time. Tape the lens so the focus doesn't wander. You won't need to refocus again for the rest of the night unless you change focal length or lenses. Each focal length focuses differently. If you change focal length on a zoom lens, you must refocus.

If the moon will not be visible on your shoot, set focus during your daytime scouting of the location. Set your focus point in the center of the frame and autofocus on a distant subject. Either tape the focus ring on the lens so it doesn't move, or mark that point on your lens so you can return to the focus point manually. To mark the point, place white stickers where the lens barrel and focusing ring meet, marking both so you can return to the focus point. Or, use pencil or nail polish to mark both parts of the lens. When you return at night, align the marks by flashlight to return to sharp focus. (Note: This will not work with some lenses that have internal focusing mechanisms.)

You can't focus on the stars simply by racking the lens to infinity. Most lenses can focus beyond infinity to compensate for temperature swings that slightly alter the spatial relationship between lens elements, changing the focus. With Canon lenses, for example, you can approximate infinity by manually focusing at the L (the infinity focus mark) on the lens. The L is on its side. Align the short part of the L above the mark for infinity by turning the focusing ring. While this doesn't guarantee perfect focus, it gets you close. Every lens has a different infinity focusing point. A few Canon lenses do not have the L for infinity focusing, so use the method of marking both parts of the lens. For Nikon, the focusing point is often part way into the infinity symbol.

To photograph at night without pre-focusing, shine a bright flashlight on a distant object and try to autofocus on it. To make your composition, you can use a flashlight to see the edges of the frame for the foreground with a small, powerful 200-lumens flashlight or a green laser light (brighter than a red one). The laser light works for focusing on a distant object as well. Be careful to never point a laser at a person, animal, or plane. People and animals can suffer significant eye damage through exposure to the light before they become aware of it, and the light can temporarily blind and disorient a pilot in a plane. Interfering with the operation of an aircraft by pointing a laser light at it is dangerous and, in many places, punishable by law.

General placement of the focusing point near the L before infinity for Canon lenses.

General placement of the focusing point for Nikon lenses.

MANUAL FOCUS WITH LCD

You can focus directly on a bright star with Live View on the LCD. Live View can magnify the scene by up to a factor of 10 so you can focus more easily. Find a bright star and place it in the center of the frame. A 4x loupe, a magnifier once used to check sharpness on slide film, makes it much easier to see small changes in the star. Make sure the loupe is covered with rubber where it touches the LCD screen to avoid scratching the surface. If needed, add some tape to the edges of the loupe where it makes contact with the screen. A 4x loupe provides sufficient magnification. The Peak brand has a square one, which works well with the LCD screen; however, a drawback is that it does not cover the entire LCD screen. Be sure to remove the clear bottom used for viewing slides.

Focus manually until the star becomes as small as possible on the screen. Its halo appears to shrink and grow as you adjust focus. The halo won't disappear, but it will shrink with the star. Don't be concerned with colored halos. This is chromatic aberration, color fringing caused by the lens, present when the focus is sharp.

HYPERFOCAL FOCUSING

Hyperfocal focusing refers to the focus point for a given focal length at a certain f-stop that maintains acceptable focus at infinity while extending focus closer to the lens. This gives greater depth of field than focusing on infinity, which doesn't allow for close focusing.

Landscape photographers use a hyperfocal focusing point to keep everything from near foreground to infinity in acceptable focus. However, focus is only perfect along one plane, which is at a given distance from the camera. The depth of field, the range of acceptable sharpness, is greater the wider the focal length of the lens, with wide-angle lenses having good depth of field and telephotos having shallow depth of field given the same aperture. Also, the smaller the aperture (such as f/16), the greater the depth of field. Depth widens as the focus point gets farther from the lens. The focusing point at which there is good depth of field from a close foreground element to infinity is hyperfocal distance.

Why not focus at the hyperfocal distance point for the stars? The idea of acceptable focus breaks down because hyperfocal distance is a compromise. The farther you get from the point of exact focus, the softer the subjects become. The lens can only focus on one point that will be sharp, with everything else having relative sharpness. If the subjects are the stars, they must be as sharp as possible, so the focus is best directly on them. If you want to learn more about hyperfocal focusing, see the Resources section.

CHECKLIST: STEPS FOR MANUALLY FOCUSING ON A STAR

- ❏ Select the focal length needed for the composition.
- ❏ Find the brightest star in the sky.
- ❏ Set focusing on the camera to the center point, so a little red square appears in the middle of the frame.
- ❏ Next, align the star or part of the moon within it. If the focal point, the star, is on the edge of the frame, optical distortion and chromatic aberration (color fringing) make it harder to focus and difficult to find in Live View. Autofocus must be on in order to see the red square in the center of the frame.
- ❏ Once the star is in the center of the frame, turn off autofocus on the lens. This prevents you from accidently engaging autofocus from the camera body after you've focused manually.
- ❏ Set the lens focus near infinity before starting to focus manually. If the lens is racked toward close focusing, the stars will be blurred to invisibility.
- ❏ Turn on Live View.
- ❏ Magnify the image to maximum, ideally 10x, making sure the star is in the magnification area. If not, use the joystick to move the focusing area to the star.
- ❏ Examine the LCD with your loupe and manually focus the lens until the star becomes as small as possible.
- ❏ Turn off Live View and take a photograph.
- ❏ Review the captured image on the LCD screen and zoom in all the way to check focus. Do not adjust the camera position when checking the focus. This way, if you need to refocus, you already have the star aligned in the center. Refocus if needed. You can also attach a monitor or laptop computer if you have trouble seeing, but for most cases, the loupe or magnified LCD work well enough.
- ❏ Tape the focus ring of the lens in place if focus tends to drift. Try removable painter's tape or gaffer's tape because they don't leave a sticky residue.
- ❏ Reframe and shoot. The focus is set for the night unless you change focal length or lenses.
- ❏ When using Live View, you may see what looks like moving noise when viewing the LCD screen for focusing. If this bothers you, reduce the ISO setting to 100 or 50. Remember to turn it back up again when taking the photograph. If your photograph is black and doesn't have a good exposure, you will know it is underexposed and you'll need to reset the ISO from 50 to a higher setting.

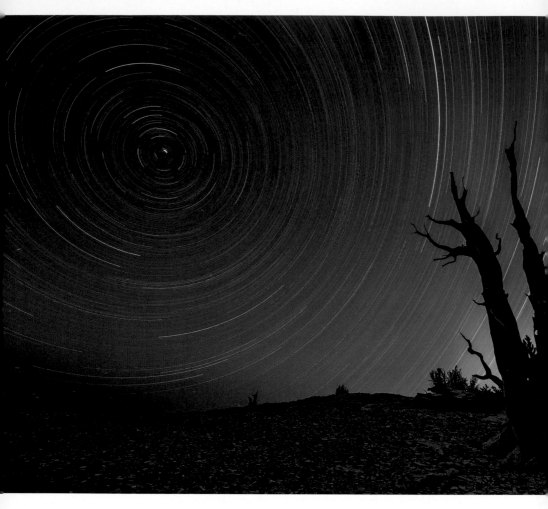

Star trails in the White Mountains, California. I focused on the stars using the manual method for doing this star trail. I placed the camera about 15 feet from the bristlecone pine tree, which allowed plenty of depth of field to get the tree and stars in good focus with the 16mm focal length. I started the photograph late, at 2:30AM, so it would finish at twilight, thus providing the pink glow on the horizon. For the composition, I pointed the camera to the north and placed Polaris, the North Star, slightly to the left in the frame. f/4, 3 hours and 4 minutes, ISO 160, EF16-35mm f/2.8L II USM at 16mm, Canon EOS 5D Mark III.

FOCUS THROUGH TRIAL AND ERROR
Finally, if none of these methods work, use trial and error. Focus on the stars as best you can, take a photograph, then review on the LCD screen at

Photographs of stars out of focus (left) and in focus (right). Blow up your first image by 10x to ensure that the stars look like dots, not doughnuts.

high magnification. Slightly move focus and take another photograph. Keep adjusting until you get the stars in focus. If the stars are out of focus, they will look bigger. With fisheye and 14mm lenses, it can be hard to focus with Live View or even get to the preset focusing point, so try prefocusing on a distant object and taping the focusing point.

5

CAMERA SETTINGS

Opposite: *Tufa stretch to the sky at Mono Lake, California. f/2.8, 25 seconds, ISO 6400, EF16–35mm f/2.8L II USM at 17mm, Canon EOS 5D Mark III.*

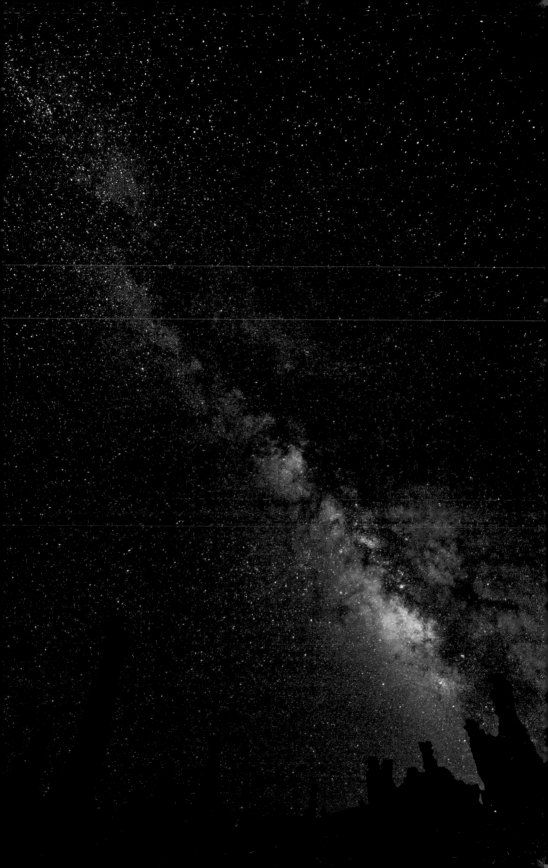

Photographing at night requires special color temperature and exposure settings. Understanding the physics of color temperature will help you get the best results in your photographs, whether you control color temperature through camera settings or primarily in post-processing. Exposure is the interaction of, and tradeoffs between, shutter speed, aperture, and ISO. As you experiment with these settings on your camera, you'll discover the settings that work best—settings that you can store in your camera's memory for your night sky photographic endeavors.

COLOR TEMPERATURE

Every light source has a particular color. This color is called the color temperature, defined as the wavelength a blackbody would radiate at a given temperature on the Kelvin (K) scale. (A blackbody is an ideal body that absorbs all electromagnetic radiation that reaches it.) The Kelvin scale measures temperature using the same increments as the Celsius scale but starts out at –273.15°C or –459.67°F, which we call absolute zero, the temperature at which the thermal energy of matter vanishes. When the temperature reaches the point at which the blackbody begins to emit visible light, it glows dull red. As the temperature increases, the color changes to yellow, white, blue, and then violet, passing out of the visible spectrum as it becomes ultraviolet. We associate the reds and oranges with warmth and the blue end of the spectrum with cold, but in physics it is exactly the opposite.

Kelvin color temperature chart

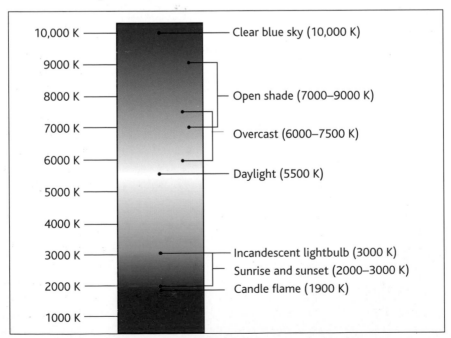

Clear, high-noon sunlight measures about 5500 K. Open shade measures from about 7000 to 9000 K while candlelight at the far red end of the spectrum measures about 1900 K. If you set your camera to its default daylight color temperature, everything looks normal under bright sun in a blue sky. However, if a canyon wall blocks the sun so that you're photographing in open shade, the subjects adopt a blue cast. A spectacular sunset at the same setting will look even richer than real life, and candlelight will look completely red.

White balance refers to the process of adjusting the color temperature so that white in the scene appears white in the image. We used to use color-correction filters to achieve this, but color temperature settings on a digital camera now take their place.

When you use JPEGs, the color balance is baked into the file. With RAW files, no color temperature information is part of the file. Instead, a set of instructions tells the RAW converter to apply a particular color temperature setting. You can change the color temperature of the RAW file at any time without affecting the file itself. We strongly encourage you to use RAW files, especially when photographing the night sky so you will have more control over color in post-processing on the computer.

While the night sky appears black, the sensor will render it from cool to warm toned depending on the time of night. None of the camera presets can control color temperature perfectly, but it may be controlled precisely by setting white balance with the Kelvin scale directly, the technique we will employ for star photography.

For star shots, go to your white balance or color temperature menu and select the Kelvin menu. Experiment with different settings to find the one that you like best. I like to set it to 3600 K, which makes the color temperature blue and is not the natural color.

The amount of color correction depends on your taste, artistic intent, or the demands of a client. From this starting point, you can easily adjust the color temperature with a slider in Adobe Camera RAW, Lightroom, or other RAW converter to enhance the blue or warm the sky. To get a feel for white balance, take some tests shots using auto, tungsten, and daylight settings.

If you want the LCD to look like the eventual print, adjust the color temperature to display that result. The color of the sky during the day is the basis of the sky at night. Just as daytime shades of blue vary, the night sky also has different shades of blue. Some days the sky looks vivid blue while on others it's imbued with cyan or a light blue-green hue. The corresponding night sky will reflect a deep blue or dull cyan blue sky in the same way it does during the day. I set the camera around 4400 K early in the evening and shift it down as low as 3200 K late in the night or when the sky isn't very blue.

If your camera doesn't permit Kelvin adjustments, try the tungsten or light bulb settings, which shift toward the blue end of the spectrum. It's also possible to adjust color temperature in a RAW converter such as Adobe Camera RAW (ACR) to achieve the look you prefer. Though you can change the color temperature in ACR, you can see the look and feel of the final result of the image on the LCD by adjusting the camera settings.

A histogram is a chart that shows the distribution of tonal values from black to white: black on the left and white on the right. For a perfectly exposed shot of a lawn under a blue sky, the chart will look like a bell curve, signifying that most of the tones are in the middle of the range. An image of a black bear would bunch the tones to the left. A white fox on snow will bunch the tones to the right. Set your LCD to show the histogram within the image or by itself after each shot.

Histogram images from Canon (left) and Nikon cameras showing ideal exposure for stars at a new moon.

Based on the histogram, an underexposed image will dramatically increase the noise when you lighten the image in processing. This will cause more noise than going to a higher ISO setting to get the proper exposure. Conversely, overexposing and reducing the exposure in processing afterward requires an excessively high and noisy ISO. Aim for the ideal histogram as shown in the illustrations. If the histogram reaches the top of the graph, it shows there is more information in this area than the graph allows. If it is cut off on the left or right side, it shows that the sensor can't capture tonal differences at the brightest and darkest extremes. It is okay to have a black spike on the left as this represents a silhouette or dark foreground.

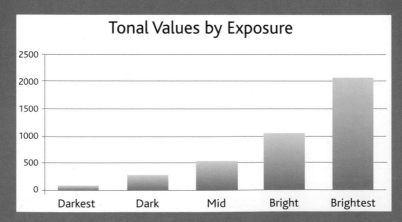

The brightest stop in the photograph contains half the tonal information. The next brightest contains half the remainder, and the darkest has the least.

EXPOSURE

Exposure is controlled by the relationship of shutter speed, aperture, and ISO. Once you have set the shutter speed for the intended result with the aperture wide open, adjust exposure by changing ISO. We need to balance the conflicting needs of each to obtain proper exposure with the least amount of noise and unintended movement blur.

For star shots, start with one stop overexposed, or slightly more, according to the meter reading using the manual mode on your camera. An ideal exposure is weighted toward the dark stops of the histogram, with the center of the curve in the second stop on a moonless night. Trust the histogram, not the LCD representation. Check your histogram after you take the photograph. Current Live View technology does a poor job of representing how an image will look when the scene is very dark. At night the screen will be black or have a high amount of noise. On some cameras a blinking on-screen symbol warns that the JPEG representation is likely not an accurate simulation. Do not base your exposure on the Live View screen to set exposure.

When reviewing your image on the LCD screen, keep in mind that your eyes have adjusted to the dim light, and what looks good is actually underexposed. Turning down screen brightness and turning off auto brightness better reflects the exposure. The stars will look fine, but the actual result could be profoundly underexposed. Recall too that vision is affected by lack of sleep, caffeine, and your general state of health.

SHOOTING WITH JENNIFER

When I shot my first image of the Milky Way, I thought the exposure was ideal until I saw a nearly black computer screen the next morning. My eyes had adjusted to the low light, so what appeared to be a good exposure was in fact almost black. Avoid this by using the histogram for determining exposure.

SHUTTER SPEED

The shutter speed needs to be fast enough to capture stars without showing motion blur, or, conversely, it needs to be long enough for star trails. See suggested shutter speeds for each type of photography in the corresponding chapters (chapters 6 through 10).

The shutter speed is displayed as 15 or 30, which represents a fraction of a second: 1/15 or 1/30 of a second. As you turn the dial to the lower numbers, they appear as, for example, 0"6 (0.6 or six-tenths of a second), 1"(1 second), or 20" (20 seconds). The "symbol indicates seconds. Common shutter speeds one stop apart are (in seconds): 30, 15, 8, 4, 2, 1, 1/2, 1/4, 1/8, 1/16, 1/32, 1/64, 1/125, 1/250, 1/500, 1/1000, etc.

APERTURE

The widest aperture allows for the lowest ISO at any given shutter speed. Although lenses are sharper when stopped down from wide open—for example, an f/1.4 lens will be sharper stopped down to f/2.8—shoot wide open to keep the ISO as low as possible. If you have a fast f/1.4 lens, you can stop down. But it's a compromise: you have to decide whether you prefer less vignetting and distortion or less noise. With all lenses, it is a good idea to stop down on a bright night with moonlight to lower distortions.

ISO

For greatest noise reduction, set the ISO as low as possible. ISO refers to the light sensitivity of the sensor, the digital equivalent of film speed. However, if you want to capture tack-sharp stars without movement, it's better in most cases to suffer with a little more noise on a higher ISO setting.

When possible (such as with moonlight), stop the lens down by one stop for less vignetting in the corners, reduced distortion, and a sharper image. There is a trade-off between increasing to a higher ISO (and more noise) and getting rid of vignetting and distortions such as wings and tails. This is personal preference; you may prefer more noise over less coma, vignetting, and chromatic aberrations. I would not recommend going over ISO 6400 when stopping down by one stop for distortions; instead, use the lower f-stop number.

On some cameras, certain ISO settings may produce less noise than other settings; these less-noisy settings are sometimes called "native ISO." With a Canon 7D, 60D, and 70D for example, the ISO settings at multiples of ISO 160, such as ISO 320, 640, and 1280, generate less noise than surrounding ISO settings. Avoid ISO 125 increments—at 125, 250, 500, 1000, 2000, 4000—as these push exposure by one-third stop and have more noise. Increments of 100 work well. When adjusting ISO, each one-stop jump in exposure has significantly more noise. If deciding between the 160 or 200 increments, go with the 160 if the exposure allows for it. For example, use 2500 instead of 3200, or 5000 instead of 6400. Test your own camera by leaving the lens cap on for a 30-second exposure at different ISO settings, and compare the results on the computer. See the sidebar for a list of ISO increments shown as multiples of 100, 125, and 160.

ISO INCREMENTS BY ONE-THIRD STOP

100 125 160 **200** 250 320 **400** 500 650 **800** 1000 1250 **1600** 2000 2500 **3200** 4000 5000 **6400** 8000 10000

Native ISO has the least amount of noise and the most dynamic range in an image to prevent clipping in the shadows or highlights. For star trails, use the native ISO setting for your camera if possible: Canon 100 ISO, Nikon 100 or 200 ISO depending on the camera, and Sony 200 ISO.

MIRROR LOCK-UP

Mirror lock-up is not needed for stars as points of light. It is a custom setting available on most cameras that swings the mirror from the sensor before, rather than during, the opening of the shutter, reducing vibration during the exposure. On a standard lens, it works best for exposures from 1/2 to 1/125 of a second long, but mirror lock-up does not provide any additional sharpness for an exposure over 1 second.

CAMERA PRESETS

The majority of modern cameras can store several groups of settings in memory. Canon calls the feature Custom Shooting Modes (C1, C2, C3) while Nikon uses Custom Shooting Bank (A, B, C, D) or U1 and U2. The Custom Shooting Bank isn't as useful because it saves only a limited number of functions. Choose one Mode, Bank, or U setting for your usual starting point, another for stars as points of light, and a third for star trails or another function.

The U1 and U2 settings on some Nikons are located on the main dial. To establish a preset, set the camera as you would for stars. Save them (Menu>Setup>Save User Settings) before you rotate the dial or power down the camera.

Canon cameras lose all adjustments you make to a saved preset if you turn the power off or if you set the camera to automatically power down after a certain elapsed time and time expires. To prevent this from happening on a shoot, set Power Time to None or 30 Minutes.

To create a preset on some Canon cameras, adjust all settings—ISO, Color Balance, etc.—needed for your shooting conditions. Press the Menu button, scroll to the wrench icon and choose Custom Shooting Mode. Select C1, C2, or C3. Press the Set button. From now on, moving the dial atop the camera to the custom setting (e.g. C1 or U1) or pressing the mode button on the 1D X camera to get to C1 will recall all those settings. Enable Auto Update, available on some cameras, if you wish to recall any changes you make to the setting.

The Canon and Nikon cameras that use the dial make it easy to save all of your night photography settings in the modes. Just turn the dial to C1 or U1 and you will be ready to shoot the stars.

Suggested star presets: Create a set for stars as points of light with manual mode at f/2.8, 20 seconds, 6400 ISO, 3600 K white balance, and noise reduction off. You can set custom modes for star trails and auroras as well. Similarly, create one for stacked star trails at a new moon with manual mode at f/2.8, Bulb setting (4 minutes), 400 ISO, 3600 K white balance, and noise reduction off. For auroras the exposure will change with the light: use manual or aperture priority mode, f/2.8, 10 seconds, 800 ISO, with noise reduction off.

6

STARS AS POINTS OF LIGHT

Opposite: *The Milky Way over Mono Lake, California.*
f/1.4, 20 seconds, ISO 3200, 24mm, Canon EOS-1D X.

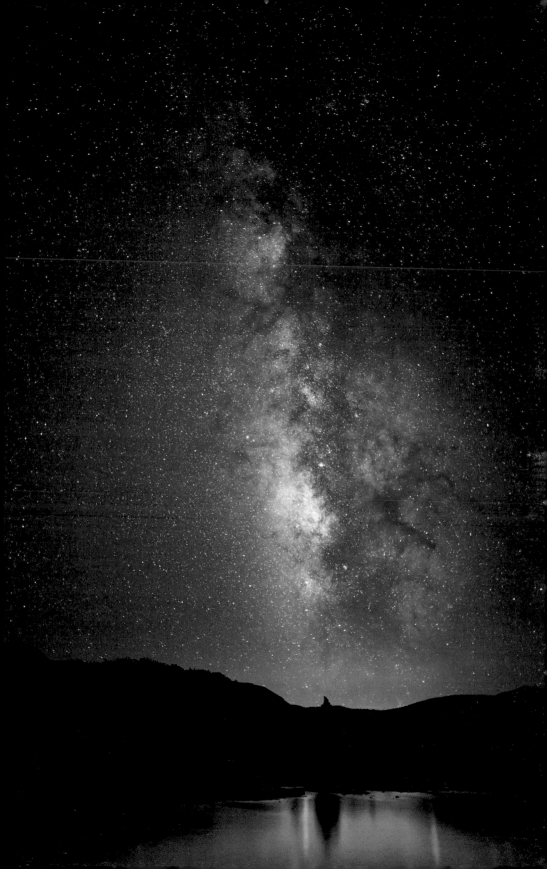

What constitutes a good image of stars as points of light? Ideally, we want sharp stars against a dark, noise-free background with at least a hint of color. To arrive at that result, we need the perfect blend of equipment, focus, color temperature, exposure, and processing.

WIDE-ANGLE LENS

Select a wide-angle lens for the scene. Photographing the stars as points of light requires stopping their movement. Longer exposures render the stars as lines instead of sharp points. The wider the angle of view, the more latitude we have, since a star takes longer to cross the frame of a wide angle of view than it does the telephoto's narrower angle of view. A wide-angle lens, between 14mm to 35mm, will yield acceptably sharp stars on a full-frame camera. For a crop sensor, try using 10mm to 22mm in focal length.

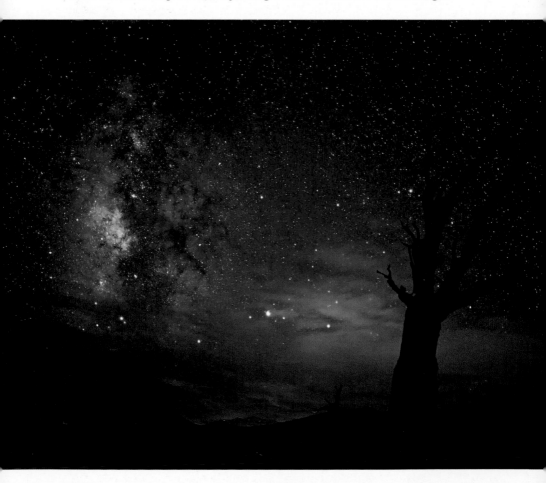

Milky Way and bristlecone pine tree, White Mountains, California. f/1.4, 20 seconds, ISO 2000, 24mm lens, Canon EOS 5D Mark II.

SHUTTER SPEED

Once you have selected your lens you can determine the shutter speeds. View the exposure on the LCD screen with full magnification. If you see movement in the stars, reduce the shutter speed by steps of one-third stop (for Canon cameras) or one-half stop (for Nikon) until the blur disappears or reaches an acceptable range. I find a little blur acceptable.

EXAMPLE SHUTTER SPEEDS

The settings listed are what I use, but they show slight movement. I find at a proper viewing distance you don't notice the slight movement. If you prefer no movement, use the next faster shutter speed than listed.

FOCAL LENGTH: FULL FRAME	FOCAL LENGTH: CROP SENSOR	SHUTTER SPEED
14mm, fisheye	n/a	30 seconds
16mm	10 mm, fisheye	25 seconds
24mm	16mm	20 seconds
35mm	22mm	15 seconds

500 RULE

Use this rule of thumb to find the minimum shutter speed required to capture stars as points of light without blurring. Divide 500 by the focal length of the lens. When shooting with a crop-sensor camera, figure out the effective focal length of the lens first. The result is a good starting point for minimum shutter speed. The 500 rule gives a general idea of the shutter speed; however, stars will move slower near the North Star and faster away from it, so review your image after you take the shot to make sure there is no movement.

For example: 500 divided by 24mm lens = 20.8 seconds, that is, a 20-second exposure.

Once the shutter speed is properly set, open the lens to its widest aperture. Then, control exposure by changing the ISO. For f/1.4 to f/2.8 lenses, expect to use ISO 800 to 6400.

APERTURE, ISO, AND EXPOSURE

For a night with no moonlight, set the aperture to wide open at f/2.8 or faster. If you have an f/1.4 lens you may prefer f/2.8 to reduce distortions by the lens. Finally, increase the ISO until you have a good exposure and a histogram that shows it. See examples in the "Exposure" section of chapter 5. Given a very dark sky with little light pollution and no moonlight, set the ISO at 6400 for a f/2.8 lens (this is underexposed, but higher ISO settings become very noisy), or 3200 for f/1.4.

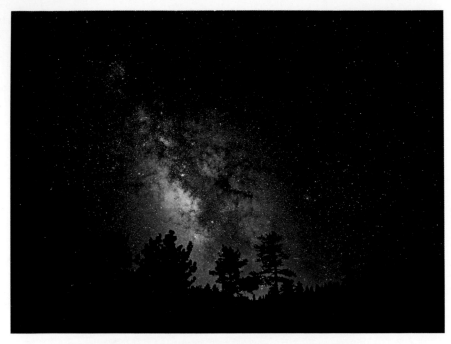

Milky Way and trees, Yosemite National Park, California. f/1.4, 20 seconds, ISO 1600, 24mm lens, Canon EOS 5D Mark II.

Review your images to make sure the stars are points of light. Left: *The shutter speed for this photograph was too slow to stop the action of the stars.* Right: *The faster shutter speed stops the action of the stars.*

The presence of moonlight requires less exposure. Use the same shutter speed to freeze movement, lowering the ISO to reduce the noise, and stopping down the aperture to minimize distortion.

Since longer lenses magnify the apparent movement of the stars, they require shorter shutter speeds, and this demands higher ISO settings, faster lenses, or both. The longer the lens, the faster the apparent movement of the stars will be. Cropped sensors reduce the angle of view, which creates a telephoto effect and the consequent need for quicker shutter speeds too. Set the white balance as desired, for example to 3600 K, or use the tungsten or lightbulb setting.

CHECKLIST: CAMERA SETTINGS FOR STARS AS POINTS OF LIGHT

❑ Verify you have a formatted memory card in camera.
❑ Set screen brightness to low.
❑ Turn off image stabilization.
❑ Turn off long exposure noise reduction, mirror lock-up, and bracketing.
❑ Set exposure to manual.
❑ Set file type to RAW or RAW plus JPEG.
❑ Use a wide-angle lens: 14mm–35mm full frame, 10mm–22mm for crop-sensor cameras.
❑ Set shutter speed to 15–30 seconds.

Full frame:	Crop sensor:
14mm at 30 seconds	10mm at 25 seconds
16mm at 25 seconds	16mm at 20 seconds
24mm at 20 seconds	22mm at 15 seconds
35mm at 15 seconds	

❑ Select a wide-open aperture: f/2.8 or faster.
❑ Set ISO: for a new moon, f/2.8 at ISO 6400; f/1.4 at ISO 3200.
❑ Set white balance to Kelvin temperature 3600 or as desired.
❑ Set focusing point to the center point, focusing on a bright star; or use the predetermined point on the lens.
❑ Tape the lens.
❑ Turn off autofocus on the lens.
❑ Take test photo and review on LCD screen.
❑ Zoom in to make sure the stars are sharp. If they look like round balls of light, they are not sharp. Refocus if necessary.
❑ Check histogram. Make sure there is information filled in on the two far-left columns; roughly the left one-third should be filled. If not, then add more exposure by increasing the ISO.
❑ Recheck the white balance. Change Kelvin temperature according to preference.
❑ Recompose as needed.
❑ Check the lens for dew.
❑ Don't breathe on the LCD screen or it will frost up in the cold
❑ Reminder: Reset for daylight photography at the end of the shoot.

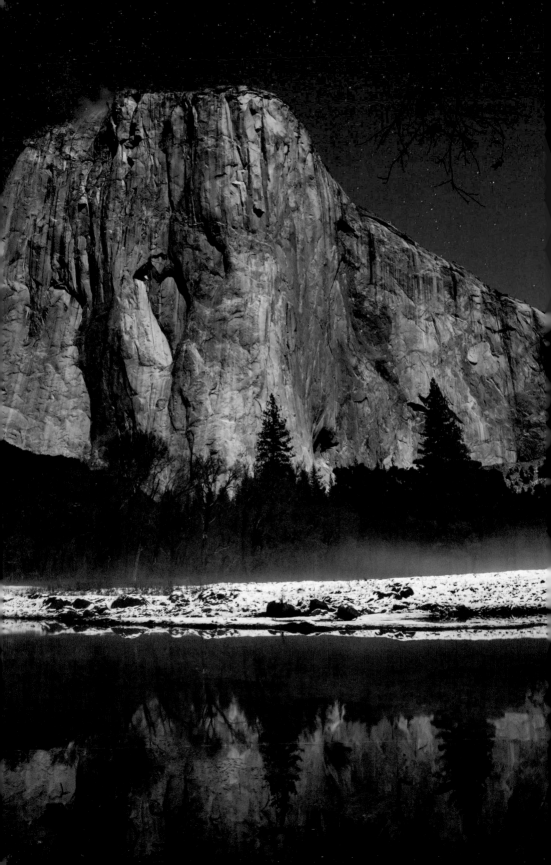

BLACK GLOVE TECHNIQUE

Sometimes the tonal range of an image is too wide to properly expose both the sky and the foreground. For example, moonlight may light a mountain adequately but leave the foreground in the shadow and underexposed. To correct for this, use an exposure appropriate for the foreground, and cover up the sky or the bright subject to preserve the stars as points of light.

Look through the viewfinder to find where to place your hand and move it up and down a little while exposing to avoid creating a solid line. A black glove isn't required. A hand works as long as no light hits it, which could show up in the photograph and cause a color tint.

First, determine the proper exposure for the sky or bright subject. Then, using that f-stop and ISO setting, lengthen the shutter speed to add more exposure for the foreground. If the camera's longest shutter speed is 30 seconds, set the shutter speed to Bulb to allow you to control exactly how long the shutter is open. Use an intervalometer to expose for the desired time, such as 45 seconds. Plan on removing your hand to expose the top half of the frame for the first exposure you calculated, while letting the foreground receive light for the full duration.

Why not use a graduated neutral density filter? This is a type of filter that is dark on top and clear on the bottom and is used to darken the exposure of the sky. This seems like a good idea; however, the proper exposure would be for the darker foreground, requiring more exposure for the image overall. To get a good exposure, the shutter speed would need to be increased, such as in the example photograph on the left in which increasing shutter speed from 20 to 30 seconds would cause the stars to blur. Alternatively, leaving the shutter speed at 20 seconds means the ISO would need to be increased to get a proper exposure, resulting in more noise. Both options result in a lower quality image, so using a neutral density filter is not recommended.

Alternatively, you could take two shots and combine them. However, it is less work to capture it in camera.

Opposite: *I used a 30-second exposure total, with only 20 seconds on the top half of the frame, which was lit by moonlight, while allowing an additional 10 seconds' exposure on the foreground, which was in shadow. At 30 seconds, the stars would be blurry with my lens choice. Yosemite National Park, California. f/4, 30 seconds, 24mm, ISO 1600, Canon EOS 5D Mark II.*

In this image, I used my hand in a thin, black liner glove held over the sky and El Capitan for 10 seconds. I set my watch to beep at 10 seconds. Once the timer sounded, I removed my hand to expose the entire image for the remaining time of 20 seconds. The top half was exposed for 20 seconds and the bottom half exposed for 30 seconds, resulting in a more balanced exposure overall.

PANORAMAS

Images of the stars as points of light evoke a sense of the vastness of our galaxy, and panoramas are a natural fit for that aesthetic. In truth, our eyes don't view the world vertically or horizontally; we see panoramas. Until now, photographing panoramas required either special equipment or manipulation of the negative or slide. Digital photography allows us to stitch together adjacent images to create a high-resolution panorama with our existing lenses and digital camera. As an added advantage, each element of the panorama adds information and increases the file size, and thus the resolution, of the finished file or print.

You can effectively increase the resolution of a low-resolution camera by stitching together three or more verticals side by side to create a single horizontal image. This image will have more than double the resolution of a single horizontal image shot with that camera.

A true panorama is at least twice as wide as a wide-angle shot. For a horizontal image, shoot three or more adjacent vertical pictures. For a vertical image, shoot three horizontal images. Stitch them together in your software during post-production. Try both horizontal and vertical panoramas of the Milky Way.

The file size of your final image will be quite large and cumbersome, especially in uncompressed formats, but it is worth it. These large files deliver the highest resolution and are ideal for very large prints, which can be spectacular.

COMPOSITION AND EXPOSURE FOR PANORAMAS

When creating a panorama, photograph in manual mode, in which you choose both aperture and shutter speed, because program mode, aperture priority, and shutter priority often change the exposure from frame to frame and that makes blending the images more difficult. Likewise, autofocus can change focus from frame to frame. So, photograph in manual mode and turn off autofocus. Determine your exposure from the middle of the panorama. This minimizes changes in brightness across the composition.

First, make sure the edges of each picture overlap by at least 30 percent of the image. This will give the software program enough common points to align the images correctly.

Second, use a tripod. While it's possible with enough ambient light to create a panorama of a series of handheld images, swiveling the camera using the horizontal movement of the tripod head will produce the most common points in adjacent images, which helps software align the images. It will also give you more usable space. If you hold the camera, you will tend to unwittingly move it vertically, creating areas that will have to be cropped out to create the final rectangle. Using a tripod also yields a larger file—in other words, more information.

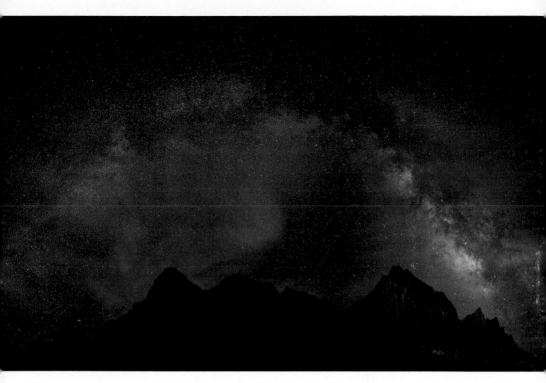

Horizontal panorama of Zion National Park, Utah. It was photographed as five vertical images to include the arch of the Milky Way. f/1.8, 20 seconds, ISO 2500 with EF 24mm f/1.4L II USM Lens, Canon EOS 5D Mark III.

Wide-angle lenses tend to bend straight lines, such as horizons, or make parallel lines, such as trees, converge. Panorama software can turn a panorama constructed from wide-angle shots into hash. Use 24mm focal length (35mm is better) or higher to avoid wide-angle distortions. For the highest resolution, shoot verticals for a horizontal image (and horizontals for a vertical image).

If you shoot in RAW format, make sure you apply identical settings to each of your images in the RAW editor. Most photo editors have provisions for applying the same settings from the previous image to the next or to batch-edit a group of pictures. Turn off auto correction and auto white balance.

The major editing programs all offer tools for creating panoramas, and a number of plug-ins exist to automate the process. As usual, Photoshop provides several methods for stitching pictures together, one of which is Photomerge. See "Photomerge for Panoramas" in chapter 11.

7

STAR TRAILS

Opposite: *Death Valley National Park, California. Two exposures combined, one focused on the foreground at f/3.5, 30 seconds, ISO 3200 and then, with the camera left in place, a second exposure focused on the stars at f/5.6, for 2 hours, 8 minutes, ISO 100. Both images 16–35mm II set to 16mm, Canon EOS-1D X. A crescent moon lit the landscape for a short while before going behind the mountain.*

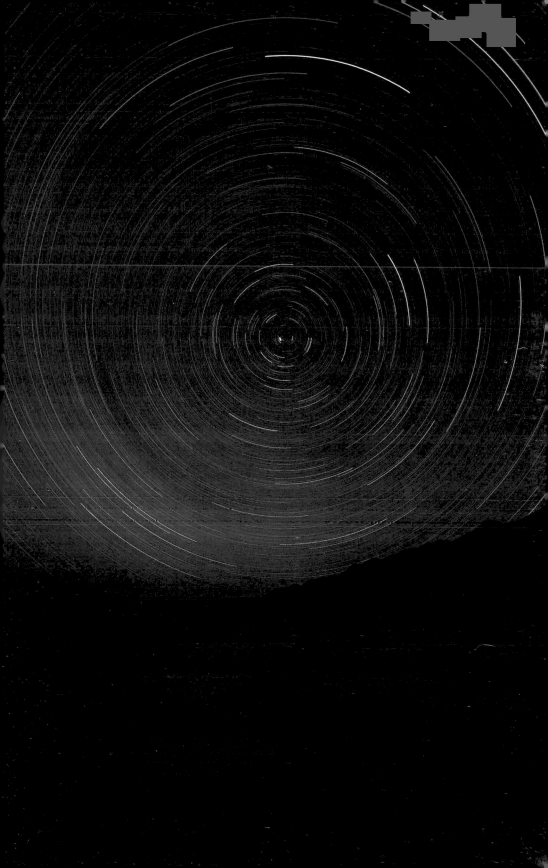

Where stars as points of light portray a moment in time, star trails evoke time's passage. Just as a meteor leaves an illuminated trail documenting its transit through the atmosphere, a matter of seconds, a star trail records the passage of all the stars in the sky over minutes or hours, like thousands of bristles on a celestial paintbrush arcing in parallel across a dark canvas.

A star-trail image can be created with a single long exposure or with many exposures layered, or stacked, to give a similar effect. In the stacked image method, instead of a single shot, we capture several or even dozens in sequence, with 2 seconds between shots. Each image portrays each star as a small arc of light. The stack of images, once merged, connects the arcs to create the curving sweep of the stars' paths. In essence, a star trail is a movie composed of many individual frames compressed into a single image.

Different focal lengths produce different effects. A wide angle captures tight curves while a telephoto shows only a few degrees of arc. Both can be effective. The telephoto's strong lines diving into the horizon are propulsive; the dramatic curves of a wide angle are dynamic and graceful.

COMPOSING THE IMAGE

For circular star trails, use a wide-angle lens to get as much of the circle as possible. Then point the camera to the north, ideally toward Polaris, also known as the North Star. The North Star will remain a point, acting as the center of the maypole. The stars spin around it in concentric circles while it remains in a fixed position in the sky.

The Big Dipper rotates near the North Star. Its position around the North Star changes with the seasons and the time of night. It can be hard to find in the fall when it's below the star, masked by the atmosphere and light scatter. If you have a compass, you can find the North Star at true north between 35 and 50 degrees above the horizon in the contiguous United States.

The side of the Dipper opposite the handle points toward the North Star. Follow the imaginary trajectory from the bottom front star of the Dipper's cup, through the upper front corner star, and on to the next bright star, Polaris.

There is no bright pole star for the Southern Hemisphere. Establish true south with a compass, accounting for declination of magnetic south. Point your camera in that direction to capture the south's concentric star trails, taking into account the angle above the horizon.

To get as much of the circle as possible, choose a wide-angle lens such as 14 or 16mm on a full-frame camera. The wider the lens, the more circles you will see. Experiment with the placement of Polaris. A centered composition looks good as does having the center of the circle off to one side, using the rule of thirds and placing it high to the right or left in the frame. Include trees or other framing elements to add interest to the star trail.

To capture stars as lines in the frame, there are many options. To get a solid diagonal line, point the camera to the east or west and use a lens with at least a 50mm focal length. To get the curvature of the lines going in opposite directions, like S-curves, use a wide-angle lens and point the camera to the east

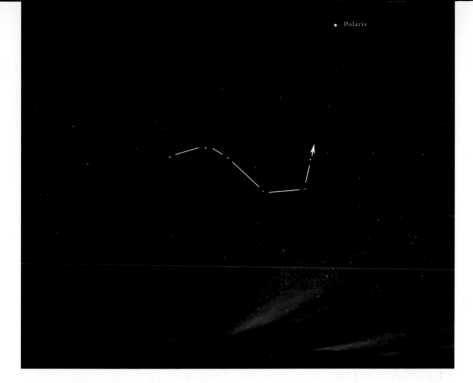

Finding Polaris. Notice the Big Dipper points to a bright star, Polaris. f/1.8, 20 seconds, ISO 1250, 24mm lens, Canon EOS 5D Mark II.

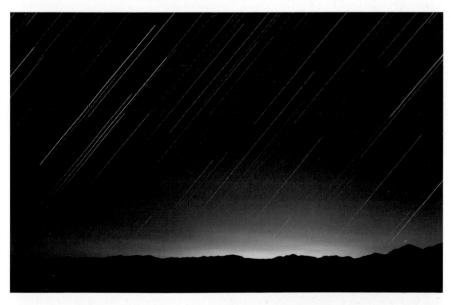

Shooting toward the east produces the diagonal lines. The warm glow is from Las Vegas lights in the distance. A total of ten exposures set to f/2.8, 4 minutes with ISO 400 and 70mm focal length, 24-70mm, Canon EOS 5D Mark II. There was a partial moon that had already set, causing fewer stars to show and more ambient light. Death Valley National Park, California.

or west. Pointing the camera to the south will have a subtle curve downward at the corners of the frame with a wide-angle lens.

SINGULAR VERSUS STACKED STAR TRAILS

There are two ways to create star trail images. One uses a single long exposure, and the other assembles a sequence of shorter exposures and merges them in post-processing after the shoot. There are advantages and disadvantages to each method. Singular star trails don't require processing of the individual frames to combine them, making them easier. A series of stacked star trails allows you to select the images you want to use in a set. If a plane flies through the scene during one of your exposures, you can start and end your sequence without the plane trails. Stacked star trails are less convincing when shot with wide-angle lenses compared to 50mm or longer focal lengths. This is because the wide-angle lenses leave tiny gaps between the star trails, and the gaps are conspicuous when enlarged to a print; however, processing methods can help with closing the gaps. I generally use a wide-angle lens for singular star trails and any focal length beyond 50mm for stacked star trails. Stacked star tails are useful when light intensity changes as the moon rises or sets, causing the exposure to change.

> **TIP**
> My digital camera batteries last about 4 hours, 15 minutes when new. Older batteries have a lower recharge performance and don't last as long, nor do cold batteries. Test your battery life before doing a singular star trail with noise reduction turned on.

DETERMINING EXPOSURE

On a dark, moonless night we see more stars, and the exposure is more consistent. When the moon is present, it bathes the landscape in wonderful light. The moonlight varies in intensity, much like the sun, and the exposure for the sky will change through the night as the moon rises or sets.

To prepare for photographing star trails, take a test shot at 30 seconds, wide-open aperture (such as f/2.8), and the ISO needed for the scene. Try 6400 or 10000 if it is a new moon, that is, with no moon in the sky. (Note that ISO 10000 is recommended only for test shots and not for final images for printing.) wIf your camera does not reach that high an ISO or you don't have f/2.8, use what you have and make adjustments as needed, such as taking a test exposure at 1 minute. Take a couple of shots until you find a good base exposure. If the moon is present, use a smaller aperture, such as f/4, because the image will be sharper at f/4 or f/5.6 than at a wide-open aperture. It will also display less vignetting and pick up more stars.

Figure out the exposure for star trails by doing a bit of math. For every doubling of the shutter speed reduce the ISO or aperture by one f-stop.

On the new moon, star trails work well at f/2.8, 4 minutes at ISO 400 to 800. You can lower the ISO, which would generate less noise, if your

lens is faster. With an f/1.4 lens, two stops faster than an f/2.8, you can use ISO 200.

Native ISO is the best choice when possible for low noise. Use the native ISO for your camera (see chapter 5, Camera Settings).

SINGULAR STAR TRAILS

As an example of how to calculate the exposure, imagine setting the ISO at 6400, the aperture to f/2.8, and the shutter speed to 30 seconds. (Note that this is about one stop underexposed at the new moon, so use ISO 10000 if you have it available.) Adjust the ISO until the exposure looks correct, that is, where the hump in the histogram covers the bottom two stops. Given the exposure settings above, the calculation would go as follows:

Start with f/2.8, 30 seconds, ISO 6400. Double the exposure time until you get the total exposure time you want to shoot. Each time you double the exposure is equivalent to one f-stop of light. For about an hour for star trails, doubling from 30 seconds to 1 minute then 2 minutes, 4 minutes, 8 minutes, 16 minutes, 32 minutes, and finally 64 minutes equals seven doublings or seven stops.

Next, take the ISO and divide by half for each f-stop, that is, divide in half seven times. Going from ISO 6400 to 3200 to 1600 to 800 to 400 to 200 to 100 to 50 gives the ISO seven f-stops lower. So ISO 50 at 64 minutes will deliver the same exposure as ISO 6400 for 30 seconds. The final exposure: f/2.8, 64 minutes, ISO 100.

The exposure will vary according to the amount of light present in the sky and the phase of the moon. If a longer exposure is desired, double the time again from 64 minutes to 128 minutes and reduce the ISO to 25 or change the f-stop. When you need an ISO lower than the lowest setting available on your camera, stop down the aperture by one f-stop. For this example, changing the exposure from f/2.8 to f/4 would deliver the proper exposure.

EXAMPLE EXPOSURE TIMES FOR SINGULAR STAR TRAIL NEAR A NEW MOON

TIME	F-STOP	ISO
32 minutes	f/4	400
64 minutes	f/4	200
2 hours, 8 minutes	f/5.6	200
4 hours, 16 minutes	f/5.6	100
or	f/8	200

For digital SLR you do not need to worry about reciprocity failure for the exposure time. Reciprocity failure shifts the colors of film and lowers the effective ISO during long exposures. If you are using film, be sure to use a longer exposure.

STACKED STAR TRAILS

To make stacked star trails, use several 4-minute exposures and combine them in post-processing. I use 4-minute exposures because anything longer tends to produce too much noise without the use of noise reduction, and the long exposure noise reduction feature will create gaps in your star trails. Recall that long exposure noise reduction works by taking a dark image of equivalent exposure time directly after your shot, resulting in long intervals between exposures that create gaps. For stacked star trails, you'll want intervals of only 2 seconds, so using long exposure noise reduction is not a good option.

Figure out the settings for your base exposure of 30 seconds, as described above. From those settings you can calculate the settings to use for your 4-minute exposures. For example: With base settings of f/2.8, 30 seconds, ISO 6400, double the time from 30 seconds to 1 minute, then 2 minutes and 4 minutes. At 4 minutes, that equals three doublings or three stops. Halve the ISO in the same manner: ISO 6400 to 3200 to 1600 to 800. That calculation yields f/2.8 for 4 minutes with ISO 800.

EXAMPLE EXPOSURE TIMES FOR STACKED STARTRAILS NEAR A NEW MOON

TIME	F-STOP	ISO
4 minutes	f/2.8	400 to 800

HOW MANY IMAGES?

For stacking star trails, use as many 4-minute exposures as you are able to photograph in a night, and decide later how many you want to include. For linear star trails, 45 minutes with a 50mm lens is a good starting point. That translates to eleven to fifteen 4-minute exposures.

WHAT ISO SETTING?

Use ISO 400 when pointing the camera east or west in the direction of the sunset or sunrise. Use ISO 800 when pointing the camera north, south, or opposite the sunset or sunrise.

Try photographing at the edge of twilight and base the exposure time on the dark night, not the exposure needed for twilight. This will allow some of the glow on the landscape to appear in the star trail. This works for both singular and stacked star trails.

I traveled with some friends to Death Valley, which is where we photographed the stacked star trails below. We went out on the first night to set up, left the cameras there in the dunes after dark, and departed to get some sleep. We returned in the morning before dawn, but we couldn't find the cameras and the dunes all seemed to look the same. Sunrise came, but still we saw no cameras. After 45 minutes of trudging through the sand we eventually spotted them. But next time: GPS!

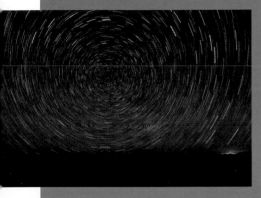
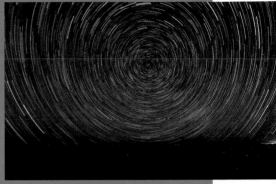

32 minutes (eight exposures).

1 hour (fifteen exposures).

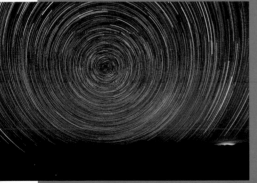
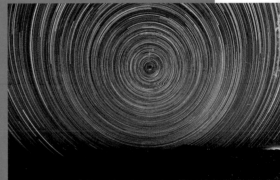

2 hours (thirty exposures).

4 hours 16 minutes (sixty-four exposures).

Example of star trails for different lengths of time at the new moon in Death Valley National Park, California. The clarity of the stars is affected by humidity, elevation, and light pollution, all of which will affect how intense the star trails will appear in your image. A total of sixty-four exposures set to f/2.8, 4 minutes with ISO 400 at 16mm. EF16–35mm f/2.8L II USM, Canon EOS 5D Mark II.

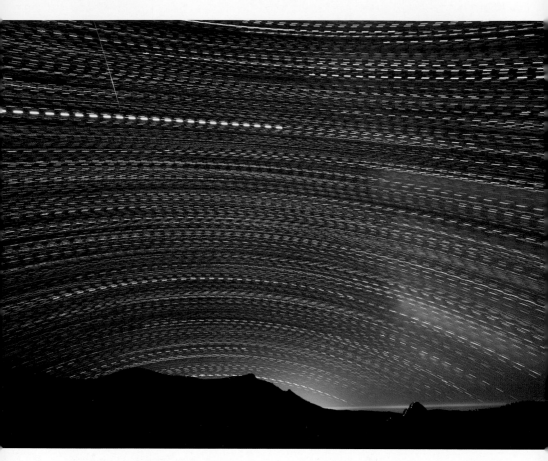

I left noise reduction on by mistake, and this image shows the gaps in the star trails that resulted. This is a view to the south, from the northern hemisphere, showing the curvature of the star trails. f/2.8, 4-minute exposures, 16mm lens, ISO 800, Canon EOS 5D Mark II.

TIP Turn on long exposure noise reduction for singular star trails and turn it off for stacked star trails. Turn off image stabilization on the lens, as it will cause the shots to be blurry. Once you have completed all your test shots, replace the battery with a fresh, fully charged one.

USING AN INTERVALOMETER OR BULB MODE

Using an intervalometer makes photographing star trails easier. It attaches to the camera and allows you to set the shutter speed, the interval between shots, and the number of frames. It has four components:

SELF: A time delay before the exposure commences like a self-timer. (I don't use this.)

INT: The interval time between exposures; used with stacked star trails.

LONG: The shutter speed or exposure time; used with both stacked and singular star trails.

FRAMES: The number of images it will take.

For a single star trail, set only the shutter speed; set it for the desired time and set the number of images to 1. For stacked star trails, set the exposure time to 4 minutes, set the number of exposures (frames) you wish to take (or leave at 0 for continuous shooting), and set the interval. Setting the interval to 2 seconds will mean that when it is done processing an image, it will wait 2 seconds before taking the next shot. You can set the intervalometer for the time you are exposing and add 2 seconds or more between frames, such as setting it for 4 minutes and 2 seconds. Be sure to factor in the processing time of your camera.

Alternatively, if you don't have an intervalometer, you can start the exposure with a remote shutter by setting the camera to the Bulb Setting. The Bulb setting, often abbreviated "B," opens the shutter and keeps it open for as long as you hold down the shutter release button. On some cameras it is a separate mode (bulb mode), and on others you set it by pressing and holding the shutter button for the exposure time you want, which needs to be at least 30 seconds to activate the setting. You may also set the Bulb setting by passing 30 seconds on the shutter speed. Next, press and hold the shutter button

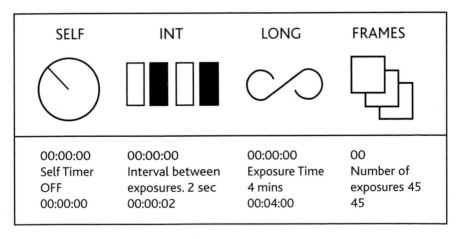

SELF	INT	LONG	FRAMES
00:00:00	00:00:00	00:00:00	00
Self Timer	Interval between	Exposure Time	Number of
OFF	exposures. 2 sec	4 mins	exposures 45
00:00:00	00:00:02	00:04:00	45

Intervalometer with example settings for stacked star trails.

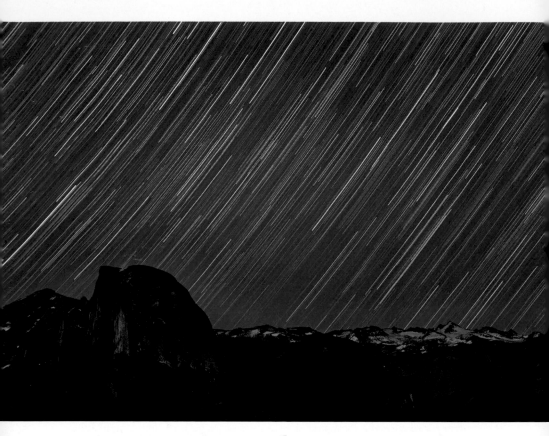

Combined image of Half Dome in Yosemite lit by the moonlight and the star trails photographed later in the evening after moonset, allowing for a darker sky and more stars. The images with the star trails rendered Half Dome and foreground very dark and without detail. Both images were taken at f/2.8, 3.5 minutes (4 minutes would be a better exposure than 3.5 minutes for star trails), ISO 800, 51mm EF24–70mm f/2.8L USM with nine stacked star trails for a total of 31.5 minutes, Canon EOS 5D Mark II.

on the remote and lock it in place. Then time the exposure. Unlock the shutter button when enough time elapses.

You may want to set an alarm on a cell phone as a reminder. Manual timing can work for a single exposure or for several 4-minute exposures when stacking star trails. If you are planning to leave the camera during the exposure and will be wearing a headlamp, note that the headlamp's light will be in the photo. Use the camera's self-timer feature to allow you enough time to move away before the exposure begins.

For details on how to process your star trails see chapter 11, Post-Processing Night Images.

CHECKLIST: CAMERA SETTINGS FOR STACKED STAR TRAILS
- ❏ Be sure you are using a fully charged battery.
- ❏ Select lens. For curved star trails, use a wide-angle lens and point camera north for circles; or point any direction for curves. For straight diagonal line trails, use a 50–85mm lens and point east or west.
- ❏ Turn off long exposure noise reduction.
- ❏ Turn off image stabilization.
- ❏ Set shutter speed to 30 seconds for test shot.
- ❏ Set aperture to f/2.8
- ❏ Set ISO. At f/2.8 on a dark night, use ISO 6400 or 10000.
- ❏ Set white balance to 3600 K.
- ❏ Focus on the stars.
- ❏ Take test photo and get a good exposure at 30 seconds.
- ❏ Calculate the settings for your 4-minute exposures based on the 30-second exposure settings in "Determining Exposure." Example exposure times for stacked star trails near a new moon: 4 minutes, f/2.8 at ISO 400–800.
- ❏ Set intervalometer for exposure time in minutes (Long setting).
- ❏ Press the start button on the intervalometer.

FOR A SINGLE STAR TRAIL, USE THE CHECKLIST ABOVE PLUS:
- ❏ Set the camera to bulb setting or use the shutter speed setting (Long) on the intervalometer.
- ❏ Turn on long exposure noise reduction.

8

THE MOON

Opposite: *The aurora borealis fills the sky with the clouds backlit by the moon, which had 40 percent of its surface visible. Mývatn, Iceland. f/2.8, 15 seconds, ISO 3200, 16–35mm, Canon EOS 5D Mark III.*

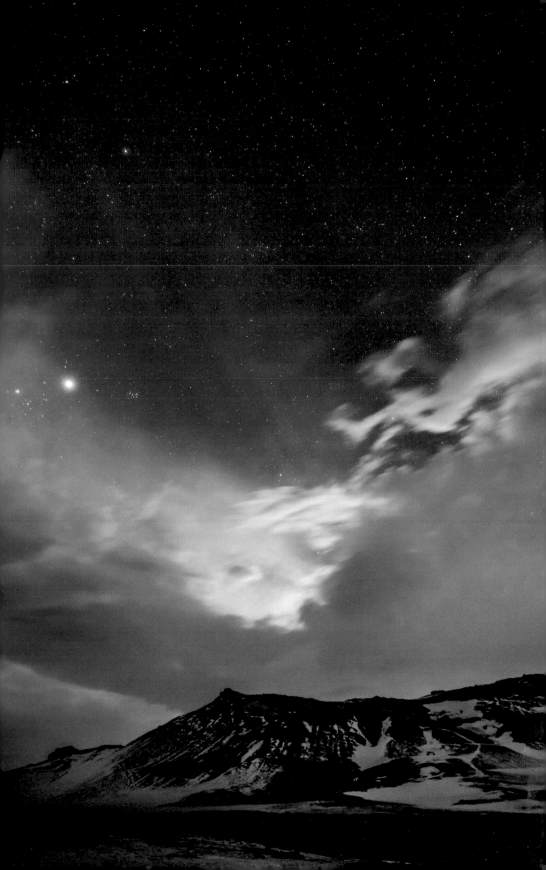

In the course of the moon's orbit, the sun lights its back, sides, and front, creating the phases. Although the moon appears to travel west with the stars, each day it rises 50 minutes later and 12 degrees of arc farther east, which slightly alters the angle of the sun on the moon so it appears to change shape day by day over a twenty-eight-day cycle.

The function of the moon in a photograph depends in part on its size. Shot with a telephoto lens, a rising moon can dominate a scene. A medium-size crescent can balance a composition. Even when reduced to a tiny bright spot when photographed with a wide-angle lens, the moon's accent can make the shot. As the brightest object in most images in which it appears, it will be a noticeable feature however it is used.

The full moon rises in the east just after sunset, while the new moon follows the setting sun over the western horizon. A full moon occurs when the entire surface facing Earth reflects the sun, with the earth almost directly between the sun and the moon. The new moon sits almost directly between the earth and the sun. Without a visible reflection, we can't see it as it follows the sun down to the horizon. The only time we see the new moon is during an eclipse and then only as a silhouette. The darkest nights, and therefore the best for brilliant star photography, occur during the new moon.

Find moon phases and times online at www.timeanddate.com or via apps such as Sun Seeker or LightTrac. See Resources at the end of the book for more options. Plan to photograph toward the direction of the moon to include it in the scene, photographing to the east at moonrise and to the west at moonset during twilight (the period just after sunset and just beore sunrise when there is some light in the sky).

DETERMINING EXPOSURE

In general, a good starting exposure for photographing the full moon is f/8, ISO 100, and shutter speed from 1/125 to 1/60 of a second. This is what I call the "looney f/8" rule. It is similar to the sunny f/16 rule: on a sunny day, use f/16 and set the shutter speed the same as the ISO. For the looney f/8 rule, I've modified the steps to open by one or two f-stops, to f/8 or f/11; some prefer f/11, but I like f/8. The exposure at f/8 would be 1/100 of a second. Round that to one of the closest shutter speeds such as 1/125 or 1/60. Use faster shutter speeds for long lenses. If you take the photograph and zoom in to find that the moon is blurry from movement, increase the shutter speed until the moon is sharp. More exposure might be needed if pollution limits the light coming down from the moon or when the moon is low on the horizon, creating lower light levels.

However, the correct exposure for the moon may underexpose the sky or foreground. In such cases, you could blend two exposures if the exposure is close, or photograph for the foreground or sky and darken the moon in post-processing.

What I photographed: The moon appears as a dot in the sky.

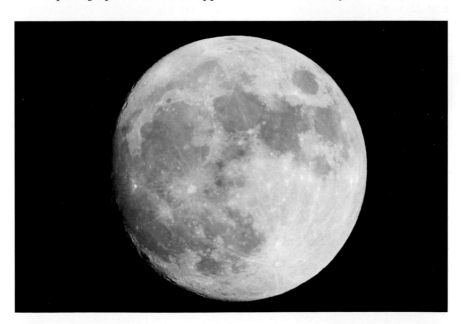

What I saw: The full moon, photographed with the 800mm lens and a 2.0x teleconverter creating a 1600mm focal length. This image is slightly cropped. When I added the 1.4x teleconverter, the moon filled the frame completely. f/13, 1/30 second, ISO 100, EF800mm f/5.6L IS USM +2.0x, +1.4x for a focal length of 2240mm, Canon EOS-1Ds Mark III.

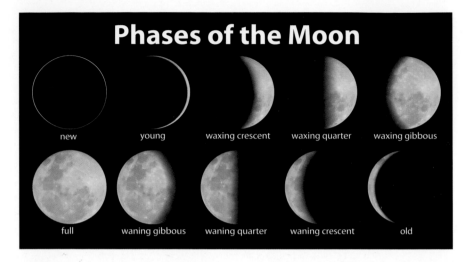

Phases of the Moon

new — young — waxing crescent — waxing quarter — waxing gibbous

full — waning gibbous — waning quarter — waning crescent — old

Keep track of the phases of the moon to find your ideal shooting conditions.
© BlueRing Media/Shutterstock.com

The correct shutter speed is partly a function of lens focal length. The moon doesn't appear to move in a wide-angle shot, but it drifts out of a 600mm frame quickly.

Use mirror lock-up with longer lenses. Without it, the vibration of the mirror flipping out of the way of the sensor sends a shiver down the lens, blurring slower exposures.

Depth of field is rarely a problem when photographing the moon without a nearby foreground, so wide apertures usually work well. As always, use the histogram to confirm that you haven't blown out the brightest parts of the picture. If the moon looks overexposed in the LCD, but the histogram shows there has been no clipping, reduce exposure or minimize the highlights in software. Unfortunately, when photographing at night, everything unlit looks black in the final result.

FULL MOON

Photographing the true full moon as it rises may lead to disappointment. On the night the full moon rises in the contiguous United States, it arrives in full darkness. Unless you can light the foreground or it's lit for you, choose a day when you can shoot in twilight. You can get some definition in the foreground and still give the impression of a night photograph.

The most beautiful full moon shots are not full moons at all. Generally they occur during the two dusks before full moon when an almost-full moon rises amid a lovely blue and pink hue. Photograph the full moon one or two nights before the night of the full moon, at twilight to the west. The same thing happens in the east during the two dawns after the full moon. Photograph the full moon the morning of the full moon or one or two days after

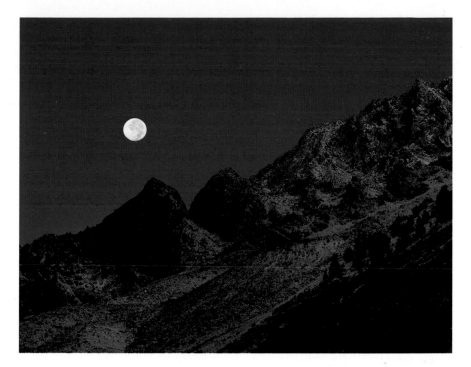

Eastern Sierra Nevada, California, two days after the full moon near sunrise. f/11, 1/25 second, ISO 100, EF70–200mm set to 200mm, Canon EOS-1Ds Mark III. Image was slightly cropped.

at dawn, when the sun is still below the horizon line. If there are mountains in the scene, it's ideal to allow two days for the moon to rise or set over the mountains. The last tints of sunset and first morning light add color to the sky and lend definition to the foreground. Check the moon setting and rising times before going to your location to see when it is best, as it varies by location and latitude. A graduated neutral density filter may be needed to balance the brightness between land and sky. Meter to the side of the moon with the filter in place, reframe, and shoot.

CRESCENT MOON

When you see the waxing (growing) moon as a slim crescent, it's always in the west after sunset, setting into the warm, orange light. Like the new moon, the waxing crescent moon is nearly in line with the earth and sun, its sunlit side facing mostly away from us, so we see only a slender lit arc, the crescent. The moon in shadow isn't perfectly black. Earthshine, light reflected from the earth, illuminates the shadow side of the moon enough for us to see it.

Each successive evening, the moon's orbital motion carries it away from the alignment of the new moon. Thus, the moon grows fatter. It also sets later so it descends into darkness instead of into warm light.

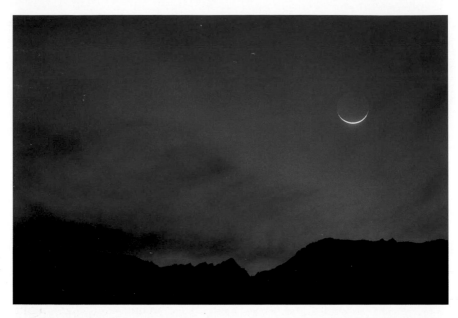

Crescent moon at sunset one day after the new moon at Death Valley National Park, California. f/4.5, 2.5 seconds, ISO 320, 70–200mm lens +1.4x teleconverter focal length 280mm, Canon EOS 5D Mark II.

Full moon one day after the full moon before sunrise at North Lake, California, with starburst effect. f/16, 30 seconds, ISO 320, 17mm TS lens, Canon EOS-1Ds Mark III.

A few mornings before the new moon, a crescent rises in the twilight to the east. The same thing happens after sunset for a few days after the new moon to the west. Photograph the crescent moon at these times. These slender crescents hang like ornaments amid the twilight tints.

A half-moon enjoys a pleasing symmetry, but a gibbous moon seems misshapen, like a deflated basketball, and not very pretty to photograph. A gibbous moon is any moon larger than a half moon but not full.

STARBURST MOON

To create a starburst moon, use a wider lens to record a smaller moon and set the aperture to f/16 or higher. At that aperture setting, the shutter's interweaving blades that open and close like an iris leave a very small opening. This causes diffraction as the light bends around the blades, generating the radiating arms of the burst. If placed well in the frame, it can balance a composition.

HALOS AND CLOUDS

When clouds and cold weather come together a colorful halo appears. Hexagonal ice crystals high in the atmosphere diffract moonlight on the clouds, creating a 22-degree ring around the moon. This is an unusually large ring in

Moon and hexagonal ice crystals. Alabama Hills, California. 1/5 second, f/5.0, ISO 400, 200mm with 100–400mm lens, Canon EOS 5D Mark II.

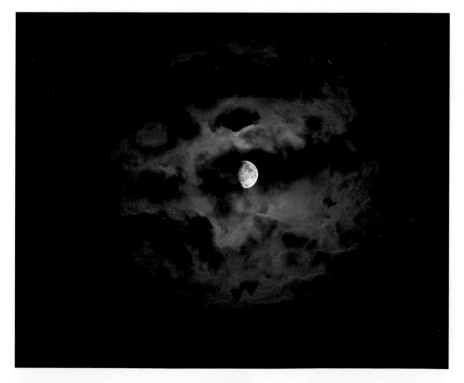

the sky that presents rare compositional opportunities. Exposure is the same as when photographing the moon.

Clouds that cover the moon yet reveal the sky can provide stunning moon rays that are much like sun rays. You can also take advantage of these conditions to capture stars in your image, though a crescent moon in the sky will allow for more stars than a full moon. Use the stars as points of light exposure recommendations for photographing late at night with clouds. This will keep the stars from becoming blurry.

ECLIPSE

The lunar eclipse happens during a full moon and features very low light with a beautiful orange color when the moon is in total eclipse. It occurs when the moon moves directly behind the earth in the shadow from the sun. The moon, earth, and sun all need to be aligned for the eclipse to block all direct sunlight.

To photograph a partial eclipse, start out with 1/250 second, f/5.6 at ISO 100. For the full eclipse, 1/2 second, f/5.6, ISO 1600. The very low light level requires the higher ISO setting. If using a long lens on a full eclipse, check that movement of the moon isn't causing it to look blurry.

You can photograph a sequence of images of the eclipse as it transitions from a full moon into the eclipse and back. The settings above are a good starting point, but they will change through the phases of the eclipse. Find an

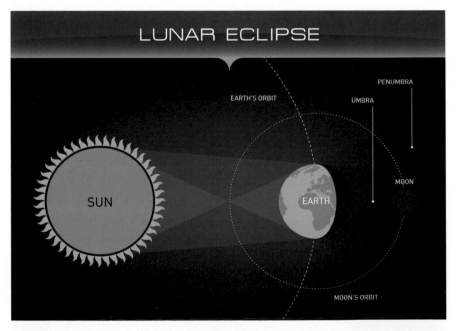

Lunar eclipse shows the moon in the shadow of the sun. © *Fluidworkshop/ Shutterstock.com*

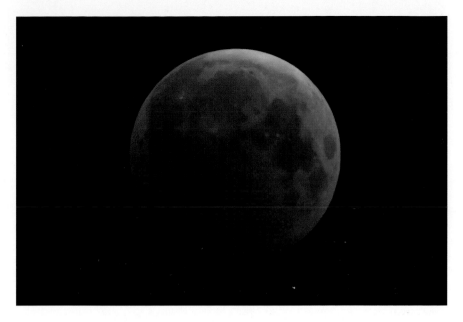

Lunar eclipse. 0.4 second, f/5.6, ISO 2000. Lens 400mm, f/4 DO IS USM +1.4x Teleconverter for 560mm actual focal length, Canon EOS 60D. Some cropping.

interesting foreground or location, take photographs at twilight to use with the eclipse photographs, then combine your images together in processing.

Check the Resources section to look up when a lunar eclipse will occur in your area. Look for a total eclipse versus a partial one. Check the path of the moon, so you can frame your shots with that movement in mind. See also eclipse.gsfc.nasa.gov/lunar.html.

MOONLIGHT

Moonlight provides light on a landscape, showing the scene in a unique way. It may be dim, but it is not soft. The moon is a small light source, the opposite of an overcast sky, and it produces hard shadows unless muted by thin clouds or other scrim.

A quarter moon or larger shining behind you can give the foreground some definition without scattering light and dimming the stars—or more precisely, reducing contrast by brightening the sky. A full moon will be very bright with fewer stars visible while transforming the scene into a surreal version of daylight. Anything reflective such as water, ice, leaves, white rocks, or glass shine more brightly in a moonlit scene.

Before you venture out, check where the moon will be in the sky, then consult a topographical map to anticipate the direction that the moonlight will fall. You can find your location on Google Maps and preview the direction you will be photographing from (photographing looking toward the

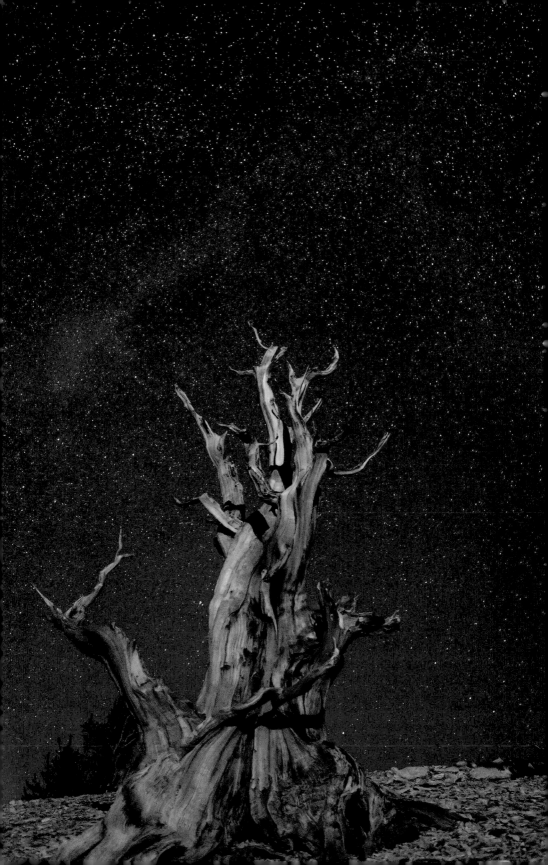

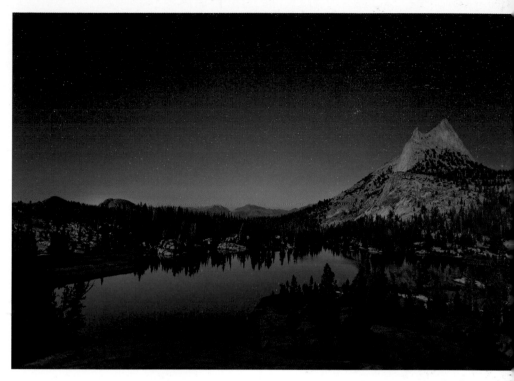

Notice the long shadows from the trees created by the low angle of the moon on the left side of the image. Moonlight is softer light when the moon is lower to the horizon and not a full moon. Remember that the position of the moon is different than that of the sun, so the shadows on the landscape at night will not be the same as those you see during the day when scouting locations. Upper Cathedral Lake, Yosemite National Park, California. This image is composed of two exposures with the low angle of the moon. They were taken within minutes of each other, one for the light in the shadows of the foreground and another for the landscape and sky. If I had only used the exposure of the landscape and sky, the foreground would have been very dark, and any attempt at lightening the foreground would have caused too much noise. Foreground exposure: 20 seconds, f/2.0, ISO 1000. Sky exposure: 20 seconds, f/1.4, ISO 500. 24mm f/1.4 lens. Canon EOS 5D Mark II.

Opposite: *Bristlecone pine tree by moonlight. f/2.8, 15 seconds, ISO 1600, 24–70mm lens set to 24mm, Canon EOS 5D.*

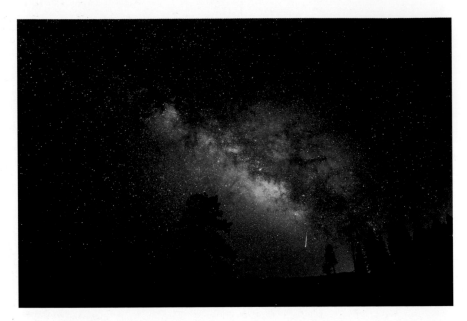

These two images were photographed from the same location, two days apart, in Yosemite National Park, California. In this image, the moon was nearly a new moon and had set behind the mountain. The small line is a meteor. f/1.4, 20 seconds, ISO 2000, 24mm lens, Canon EOS 5D Mark II.

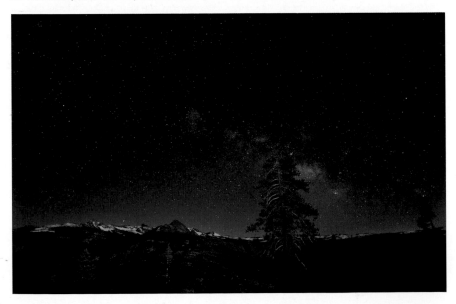

Here, the moon was a waxing crescent so about 35% of its surface was visible. Moonlight on the landscape shows us the details in the scene. f/2.0, 20 seconds, ISO 1600, 24mm lens, Canon EOS 5D Mark II.

These two images were photographed in Yosemite National Park, California, on the same night and moments apart. I took the photograph of the mountain and turned 90 degrees counterclockwise to get the photograph of the tree.

Right: *This demonstrates the strength of frontal light. The moon was behind me and slightly to the right, as you can see from the gradation of shadow on the tree. f/1.4, 20 seconds, ISO 800, 24mm lens, Canon EOS 5D Mark II.*

Below: *Moonlight creates different moods depending on the type of light. Sidelight is hazy and dimmer on the mountains than frontal light. The moon was to the right of the frame. f/1.4, 20 seconds, ISO 500, 24mm lens, Canon EOS 5D Mark II.*

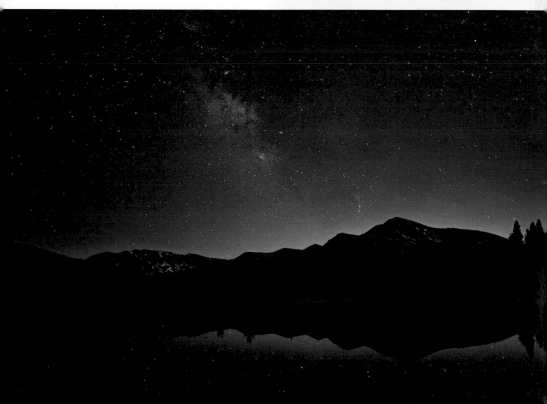

southwest), or you can buy topo maps at outdoor recreation stores. Another good option is to use the Photographer's Ephemeris, at stephentrainor.com /tools, which uses Google Maps and places the path of the sun and moon directly over it showing the direction of the moon as well as the angle of its rise. See Resources for more information.

When photographing by moonlight, look where the moon is in the sky and photograph in the opposite direction for the light on the landscape. The angle and height of the moon create different qualities of light. About a week or two after the full moon, the moon rises from the east after sunset. Plan to take your photographs facing west when it comes up in the sky for frontal lighting.

Frontal light, when the moon is directly behind you or slightly to one side, is a strong light source that works well to illuminate the landscape. Sidelight from the moon is not as bright, but it creates well-defined shadows. Extreme sidelight can look hazy if the moon is just outside the edge of the frame.

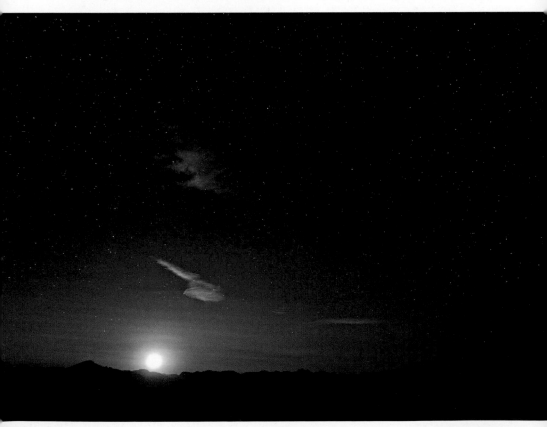

As the moon sets in Yosemite National Park, its glow is enhanced by a few wispy clouds, making it look almost like the sun. If you try this with the sun, the strong light source with make the stars invisible. f/2.2, 10 seconds, ISO 1600, 24mm lens and Canon EOS 5D Mark II.

When the moon is low in the sky and near the horizon, it casts long shadows with lower light levels. When the moon is higher in the sky, a stronger light produces shorter shadows. The shadows are similar to what we see in sunlight at sunset versus midday light, except with less intensity or color glow.

MOONBOWS

In misty conditions around the time of the full moon, moonlight creates moonbows, also called lunar bows. They curve like rainbows but appear as white bands of light to the naked eye. Though they are not bright enough for most of us to see in color, the camera is able to capture their colors.

Particular conditions must be met to produce a moonbow, making them rarer than rainbows. Like rainbows, they appear when there is moisture in the air. Moonbows require the brightest of moons to be visible, a full or nearly full moon, in a sky free from clouds or haze that could block the light and from light pollution that could overwhelm them.

Moonbows are seen directly opposite the moon, so look in the direction of your shadow. They are stronger when the moon is lower on the horizon and fade as the mood rises higher in the sky.

One way to try to anticipate moonbows is to use the Photographer's Ephemeris: photoephemeris.com (desktop version or app). Choose your location, select your date, click on details, and see when the moon will be in the sky by sliding the time-frame arrow to the right and looking at the degrees of the moon.

To photograph the moonbow, use the same settings needed to shoot a landscape under the full moon. Since a wide-open aperture such as f/2.8 will suffer from vignetting and chromatic aberration, stop down to f/4. The full moon will provide plenty of light. Start with manual mode at f/4, 30 seconds, and ISO 800 to 1000. Bracket your exposure from this starting point.

Moonbows can be predicted where there are waterfalls because the mist will guarantee a moonbow with direct, full-moon light. When researching locations for waterfalls, look for falls that receive light from the moon: in the Northern Hemisphere, waterfalls facing southeast or south for photographing after sunset and waterfalls facing south or southwest for before sunrise; or for the Southern Hemisphere, falls facing north. See Resources.

Moonbows work best with large waterfalls that have a significant amount of spray. Spring is the time of year with the greatest water volume. Some good waterfalls for moonbows include Cumberland Falls in Kentucky; Victoria Falls on the border of Zambia and Zimbabwe; Skógafoss in Iceland; and Yosemite Falls, Bridalveil Fall, and Cascade Falls in or near Yosemite National Park in California. In my opinion, Niagara Falls has too much light pollution.

Be prepared to protect yourself and the camera from wind and the mist from the falls. If the water flow is heavy, wear a raincoat, rain pants, and waterproof shoes. Use a rain cover for your camera. As an added precaution, bring a small, highly absorbent pack towel and a chamois. Watch out for water on the lens from the spray of the waterfall, and, if needed, use the

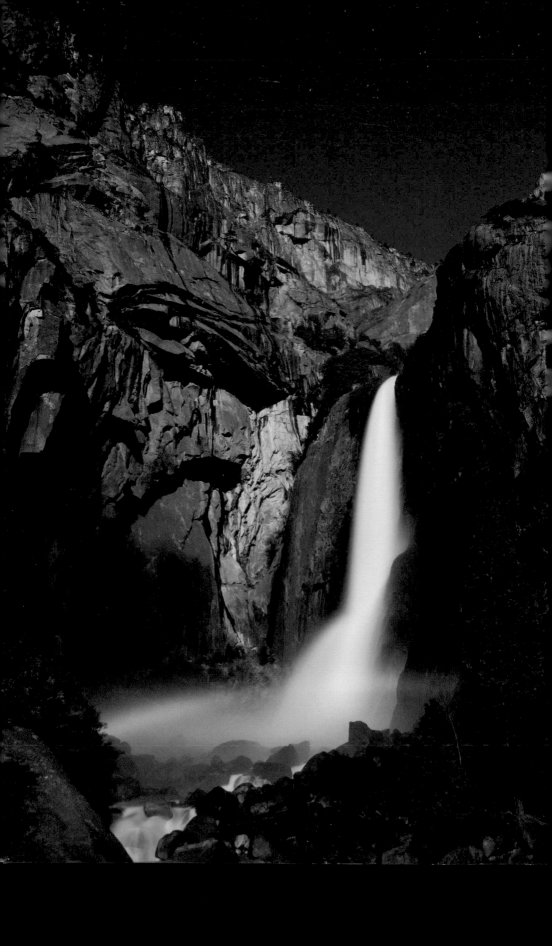

towel to mop water off the camera or lens and finish drying the lens with the chamois.

Before you get to the falls, apply all your camera settings, focus on the moon, and tape the lens in place. Put the rain cover on the camera. It is difficult to focus through the mist, and getting everything ready before you arrive at the falls prevents the lens from getting wet while focusing. Scout the area for a spot that still doesn't have too much mist but still has a view of the moonbow.

Opposite: *Moonbow and Yosemite Falls, Yosemite National Park, California. This location is extremely busy with many photographers, so be prepared for the crowds. f/4.0, 20 seconds, ISO 1000, 30mm, 24–70mm, Canon EOS 5D Mark II. Another composition would be to use a 14mm lens and include more of the sky in the frame. (The Big Dipper is visible from Yosemite Falls.) For moonbow prediction times for Yosemite National Park, see uweb.txstate .edu/~do01/moonbows2010.html.*

9

TWILIGHT

Opposite: *The Belt of Venus at twilight in Namibia.*
f/11, 3.2 seconds, ISO 100, 24-70mm II at 24mm,
Canon EOS 5D Mark III.

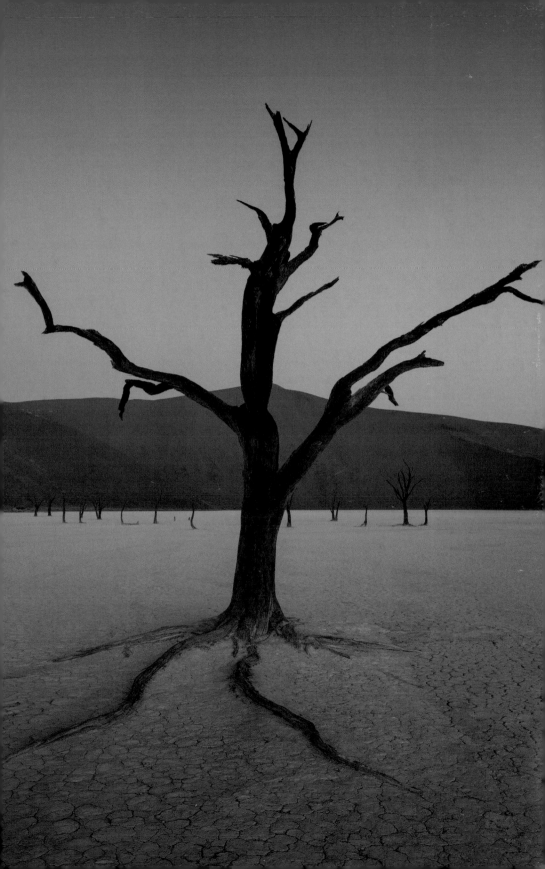

Twilight is commonly thought of as the period just before sunset but it also refers to the time just before sunrise. During twilight, light shifts from warm to cool, from yellow to blue. Without strong light, harsh contrast disappears and colors seem to glow internally. Minute by minute, blue and pink tones intermingle, with blue gaining dominance until the sky dims and the faintest tones seep away, replaced by the cobalt blue of night. Before sunrise, of course, this evolution of the light is reversed, but with the same dramatic effects for photography.

Twilight is also called the blue hour, but its actual duration depends on latitude and season. Near the equator, twilight lasts about twenty minutes year-round. Above the Arctic Circle, however, the midnight sun forestalls twilight. In midwinter the pole abides in darkness, and around the Arctic Circle twilight is extended, with less light during the day.

When the sky is still bright enough to appear rich blue before full darkness, the most beautiful light appears on the horizon opposite the sunset, a strip of red light sandwiched between the dark blue band below and a blue gradient

A long exposure creates the misty look of the ocean surf at twilight, near Oahu, Hawaii. f/16, 20 seconds, ISO 100, 24mm lens, Canon EOS 5D Mark II.

The pink glow of the Belt of Venus photographed looking northwest at Lake Tahoe, Nevada. f/16, 1.6 seconds, ISO 160, 15mm on a crop-sensor camera. Notice the curvature created by the fisheye lens, an EF8–15mm fisheye, Canon EOS 7D.

The same scene by night. f/4, 20 seconds, ISO 3200, 15mm on a crop-sensor camera shows the curvature of the lens, an EF8–15mm fisheye, Canon EOS 7D.

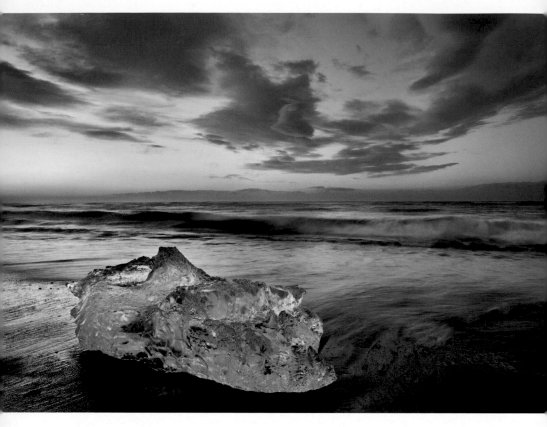

Pink clouds glow at twilight, Jökulsárlón, Iceland. f/16, 1/80 second, ISO 100, 25mm, 24–70mm, Canon EOS-1Ds Mark III.

above. This is the Belt of Venus. It is composed of red light from the sun refracted through the atmosphere and cut off on the bottom by the shadow of the earth. Look for it five to twenty minutes—or longer in high latitudes—after sunset and before sunrise. The deepest pink hues occur at twilight opposite the sun. At sunrise look for it to the west or northwest, and at sunset look for it to the east or southeast, depending on your location.

At times the planet Venus, also called the morning star, shines with unnatural brightness, preceding the sun on the eastern horizon before sunrise. Venus then disappears in the sky as sunlight overwhelms it or, at other times, as it follows the sun below the horizon after sunset.

DETERMINING EXPOSURE

Photographing a twilight scene on any automatic setting or according to the meter in manual mode will result in an apparently overexposed image on the LCD because meters average a scene to correspond with neutral gray, halfway between pure white and absolute black. The meter sees a twilight

scene as underexposed and brightens it to neutral gray. An exposure where the LCD matches the scene requires a one- to two-stop underexposure, but even that won't yield an optimal exposure. The best solution is to slightly overexpose the image. A slightly overexposed image captures more information and will produce less noise, but the exposure will need to be reduced in post-processing.

The foreground is often much darker than the sky, but a two-stop neutral density filter can balance the exposure. As twilight moves toward night, it becomes harder to focus. Use a flashlight to illuminate the foreground for focusing.

URBAN NIGHTS

Cityscapes look more dramatic against a twilight sky. Pure black night is a dull backdrop, and the contrast between city lights and sky is too harsh. The light from the city overpowers the stars as well. But there is a point during twilight at which the light is balanced between the city lights and sky so that the lights may not be blown out and the sky is not too dark. This can be hard to see with your eyes, but the camera will pick it up, so keep photographing through twilight until the balance of light looks good. Review your images while photographing and look for a deep cobalt blue color. The blue color lasts a long time, but it only gets deep blue for a few minutes. If the lights are not balanced with the sky, take two photographs, one for the building lights and one for the sky, then combine them in post-processing.

Including a road with streaks of the car lights can add interest to a city scene. Increase streaks by using a longer shutter speed, either by lowering the ISO, stopping down (f/16), or using a neutral density filter. Be careful of headlights shining unexpectedly into the frame.

WORKING WITH CITY LIGHTS

Yellow lights are sodium vapor lights that appear yellow or orange to the camera. They are the most common kind of streetlights. Use the tungsten or light bulb setting to correct for this or dial in a Kelvin temperature setting toward 4000 K or lower.

Green lights are mercury vapor lights that the camera sees as green. Often found in older cities or older neighborhoods, they are used for streetlights and

SHOOTING WITH JENNIFER

Before sunrise is one of my favorite times to photograph, especially the Belt of Venus. The soft and colorful light gives the landscape a peaceful and subtle quality. I prefer it over sunset for some reason; perhaps the air is cleaner or it's just the stillness of the morning. Wilderness photographer Galen Rowell used to say, "Most people arrive too late and leave too early," and I agree!

Bay at San Sebastian, Spain. The curvature of the fisheye lens adds interest to the scene. f/16, 30 seconds, ISO 125, 8–15mm fisheye set at 15mm, Canon EOS 5D Mark II.

Golden Gate Bridge at twilight using a fisheye lens on a crop-sensor camera. The camera is fairly level, so the lens does not show as much barrel distortion as it would if it were pointed up or down. f/11, 2 seconds, ISO 640, 8–15mm fisheye set at 15mm, Canon EOS 7D.

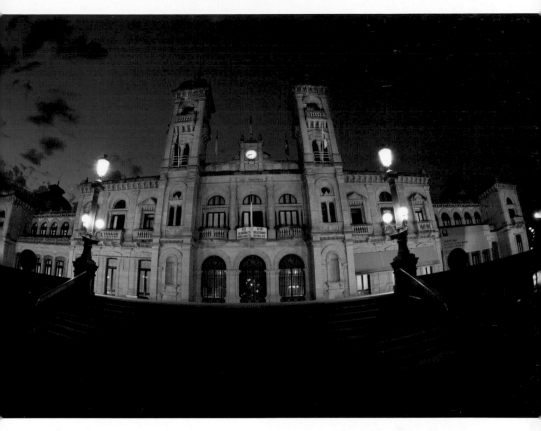

San Sebastian, Spain, at twilight with the deep cobalt blue of the night. Notice the curvature created by the fisheye lens. f/16, 3.2 seconds, ISO 100, EF8–15mm fisheye set at 15mm, Canon EOS 5D Mark II.

for lighting large outdoor areas. Shifting tint toward magenta when processing the photographs or using the custom white balance feature in the camera corrects the color toward neutral.

Multicolored lights in your image come from various light sources in the scene. In some places, city lights have many colors, such as those in the brightest spot on Earth, Las Vegas. To color-correct, determine the color temperature of the main light source, perhaps yellow or green, and correct as needed, or convert the image to black and white to eliminate the multiple colors. The other lights may be off but the main lights define the character of the image.

10

CELESTIAL PHENOMENA

Opposite: *Aurora borealis with river. Brooks Range, Alaska. f/2.8, 20 seconds, ISO 1000, 16mm, EF16–35mm f/2.8L II USM, Canon EOS 5D Mark II.*

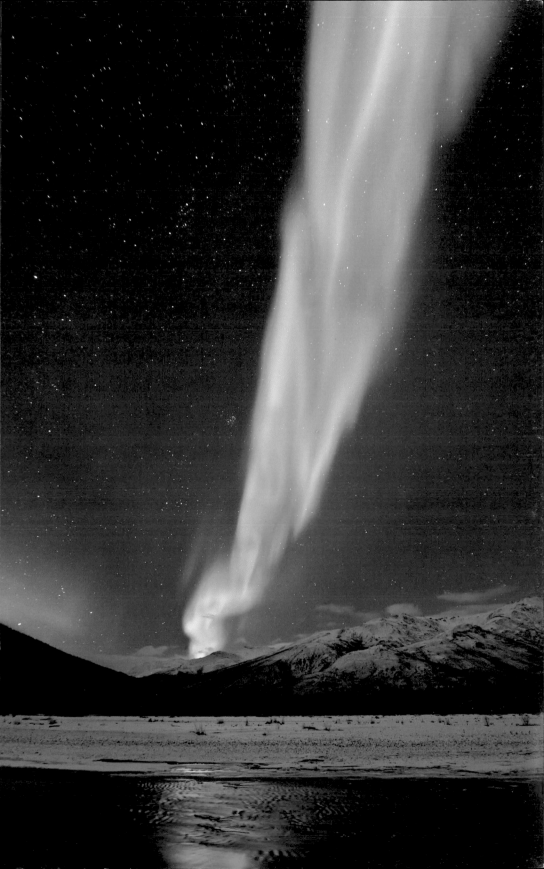

It could be said that the mysteriousness of the night sky is embodied most in the mercurial celestial phenomena that illuminate it: zodiacal light forming a glow on the horizon like a mythical city, iridium flares mimicking a shooting star, the brilliant trail of a meteoroid disintegrating in the atmosphere, the shades of color reflecting off of noctilucent clouds, or the dancing curtains of green light that typify auroras. Though not of the sky, volcanoes have been included here because, in terms of night photography, their fire-lit emissions have much in common with celestial phenomena.

If you have ever wondered how to catch a shooting star, the key may well be in learning the art of photographing celestial events like these. The unpredictable nature of celestial phenomenon adds thrill to the hunt and gives speed and luck greater-than-usual importance.

ZODIACAL LIGHT

On very dark nights around the time of the equinoxes, the horizon may glow with a colorless triangle of light about an hour before dawn in the fall and an hour after sunset in the spring. It looks like the radiance of a distant city but with a conical shape. This is zodiacal light, or the false dawn.

Sunlight reflects off a disk-shaped cloud of dust found along the orbits of the planets, the path through the constellations of the zodiac. The dust cloud extends past Mars. Its particles are the remains of the solar system's creation.

Because zodiacal light is so faint, any amount of light pollution will obscure it, even moonlight. Zodiacal light is brightest in the latitudes from 30 degrees north to 30 degrees south, which includes the most southerly parts of the United States.

To capture the false dawn, use the same camera settings as you would when photographing stars as points of light.

IRIDIUM FLARES

Iridium or satellite flares are also called satellite glints. The glinting occurs when the sunlight bounces off the reflective satellite antenna surfaces back to earth and creates a flash of light that looks like a meteor. The Heavens Above website (www.heavens-above.com) and others listed in the Resources section can tell you when and where the flares will occur, so you can get a meteor-like photograph at a predicted time. The flares can be very bright and there is usually at least one bright flare each week apparent from most locations in the world. In fact, flares are visible almost every night from most locations, usually seen two or three hours after sunset or before sunrise. You will need to know the longitude and latitude of your location. Check out the website on iridium flares and look at the FAQ section of Heavens Above on iridium flares to interpret the chart.

METEORS

When a meteoroid enters the earth's atmosphere, frictional heat burns the object, creating a bright ionization trail tracing its path, which is called a

SHOOTING WITH JENNIFER

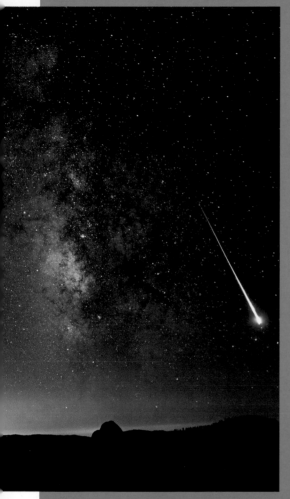

Shooting star over Half Dome, Yosemite National Park, California. f/1.4, 20 seconds, ISO 1600, 24mm lens, Canon EOS 5D Mark II.

I wanted to photograph meteors from Olmsted Point in Yosemite National Park, high in the mountains, for more stars in the sky and a good view down a canyon to Half Dome.

This was photographed on August 12, 2010, at the peak of the Perseid meteor shower. The showers are visible annually from mid-July through the peak around August 12 and 13. The best viewing is in the morning hours before it becomes too bright to see them, but they are visible all night.

I had photographed the Perseids for a few days the previous year, and while I did get some meteor shots, I didn't get the one I was hoping for. There were two really big meteors those nights, but I was pointing the camera in a different direction or changing a lens.

For this image, I headed out to photograph the meteor shower and stayed up all night for several nights in a row. For two nights until dawn, I set up two cameras pointing in different directions with the intervalometer set to a 2-second interval for continuous photographing. The night I photographed this, a friend called me while I was taking this shot. We were both watching the meteors and saw a really large one at the same time. Fortunately, one of my cameras was pointed in the right direction. When I went to look at the image on the back of the camera, I screamed, "I got it!"

meteor. (This was once the name for the object itself.) Meteoroids are comet debris composed of metals (90 percent iron) and stone. Millions of meteoroids enter our atmosphere daily, most ranging in size from a grain of sand up to a pebble, with some several feet across. Typically they incinerate before impact. Meteoroids orbit the sun like comets in immense elliptical paths. When a large grouping swings near the earth, swarms of meteoroids light up the night sky. This is called a meteor shower. Single meteors are often called shooting stars or falling stars.

A meteor-hunting photographer depends on an equal measure of luck and planning. The best time to capture meteor pictures is during a meteor shower. During the height of the largest showers, meteors may streak across the sky a couple of times a minute. With luck, a few larger ones may paint a wide arc.

Meteor showers emanate from particular constellations. Set up with the best foreground for that direction, frame the image to include the constellation with the surrounding area, and program your intervalometer to shoot frame after frame for several hours.

If you live in the Northern Hemisphere, good news: more major meteor showers appear in the north than the south. But not all showers are created equal. The Quadrantids in January produce over one hundred meteors an hour, but they tend to be faint. April often brings brighter meteors but in small numbers. Around August 12 and 13, the Leonids yield somewhat fewer meteors, but they are easier to see. The meteors appear from the Perseus constellation, so look toward the northeast. The Taurids in November produce only a few meteors per hour, but some are real fireballs formed by unusually large meteoroids. In the north, the Leonids put on a good display around November 17th. While you can expect more meteors to appear in the direction of the meteor shower's namesake constellation, they can appear anywhere in the sky.

Look for a meteor shower that occurs when the moon is not full. The darkness of the new moon allows fainter meteoroids to be visible and brighter ones to be spectacular, but a half-moon supplying some light on the landscape also works. Photographing the shower away from city lights will produce a darker sky and stronger meteor light in the image. City lights in the distance endow the scene with a warm, sunset-like rim light along the horizon.

Approach meteor photography as you would stars as points of light. The techniques and settings are identical. At the end of the shoot, you'll have hundreds of images to review, but with luck you will have caught a well-placed meteor in your photographic net. The shorter 15- to 30-second exposures work best for allowing the meteor to be bright in the image. Using an exposure of a few minutes will result in a dim meteor in the frame—it may not even show up at all.

Increase your chances of photographing a meteor, especially a really big one, by taking shots continuously. Use the intervalometer and set the interval between frames for 2 seconds. Keep all the other settings on the intervalometer set to 0 and press the start button. Press the stop button when you are done.

Be sure to have a fully charged battery and plenty of extra memory cards if you are going to be out all night. If you have two cameras, set them up in different directions.

You can tell plane trails from meteors as plane trails are white or red with abrupt starting and ending points. A meteor often has a green color at the start with a white tip that tapers out.

NOCTILUCENT CLOUDS

Noctilucent clouds are the highest clouds in the atmosphere, floating 50 miles above the earth's surface near the poles. Often blue or white, we can see them glow in deep twilight as the sun illuminates them while we are in the earth's shadow. They are viewable between 50 and 70 degrees latitude in both the Northern and Southern Hemispheres. Noctilucent clouds were discovered in the nineteenth century and are becoming more frequent, perhaps as a result of climate change.

Because they are so faint, they can only be seen on very dark nights. Try long exposures at high ISO speeds with the lens wide open, if you're lucky enough to encounter them.

AURORAS

Auroras are lights created by charged particles from the solar wind drawn into the atmosphere near the poles by the earth's magnetic field. The aurora borealis forms around the North Pole and the aurora australis around the South Pole. They are generally brightest not at the poles, but in bands about 3 to 6 degrees of latitude away from the poles. During high sunspot activity, when the amount of charged particles spikes, they can even be seen in parts of the contiguous United States. To see the aurora, the most important factor is to be near this band of activity.

Some of the best and easiest-to-reach locations for photographing auroras include Fairbanks, Alaska; Jökulsárlón, Iceland; Tromsø, Norway; Whitehorse and Dawson City in the Yukon, and Yellowknife in the Northwest Territories, Canada; Kangerlussuaq, Greenland; and Jukkasjärvi, Sweden. Remember to get away from city lights and other sources of light pollution.

Some auroras are little more than gauzy glowing regions in the sky. Discrete auroras are well defined, flowing like curtains in a breeze. Auroras are usually green but some glow white, red, violet, or a combination of all three.

For reasons not entirely clear, the time periods around the equinoxes (March–April and September–October) tend to have more auroral activity. In the summer at latitudes close to the poles, the sky does not get dark enough to see auroras; however, a big solar storm may extend the range of auroras as far as halfway to the equator.

Consider any phase of the moon for photographing auroras. A bright moon will wash out the stars but its light will define the landscape. The dark of new moon reveals the most intense color, but the foreground landscape may become a silhouette unless you do some light-painting. Light from the auroras

can apply some definition to the landscape depending on the intensity and direction of the aurora.

Figure out the location of the moon before you go out. If it's positioned in the same area as the auroras, it will likely be in your frame. With a wide-open aperture, the moon will become a big washed-out blob or produce lens flare. At f/16, a small, full moon gives a star effect, a nice accent in the composition. Clouds covering the moon can provide interest.

Auroras are most active from 10 PM to 2 AM, but can be seen at any time at night. Don't pack up your bags when the auroras first disappear since they may reappear later. Wait it out. Often, auroras last about half an hour and recur every two hours when activity is high, but they may also continue for hours or not appear at all. Auroras are not constant phenomena. They come in waves during the evening, called auroral substorms.

The intensity and frequency of auroras depends on the eleven-year sunspot cycle. Both sunspots and solar flares arise from intense magnetic disturbances. The year 2024 will be the next peak year. At the height of the cycle, auroras appear brighter and with greater frequency, but auroras persist, at reduced frequency, throughout the cycle.

The sun produces more and larger solar flares at the peak of the cycle. The sun ejects a stream of electrons, ions, and atoms, briefly sending as much as one-sixth of its total energy into space during the flare. This releases as much energy as many millions of volcanic eruptions. When the particles interact with the atmosphere, we see the resulting auroras.

For the daily aurora forecast, check out this website: www.gedds.alaska .edu/AuroraForecast/, or the Aurora Forecast app. Keep in mind this is just a forecast, so you can get bright lights even on a night predicted to have low likelihood. It is still worth waiting for, so don't sleep in just because you see that the forecast predicts a level 1, as the aurora might turn out to be really beautiful. Our cameras see more than our eyes can see. Sometimes you can see light aurora activity in the photograph with green, purple, or red colors that you can't see with your eyes.

If you are out at night waiting for the aurora, stay in the car so you don't get chilled. Keep looking in all directions for auroras from the car. Turn off the inside car lights so as not to disturb your night vision, or replace them with a red light bulb or use a red gel over the lights. If you are outside and waiting for auroras, keep the lens cap on to prevent frost and dew accumulation, or point the camera lens down to keep frost to a minimum.

Auroras are much brighter than the stars but move faster. Wide angles give you enough space to capture the aurora without giving it time to wander out of the frame.

Where in the sky should you look for the aurora? The best regions are in the northwest or southeast parts of the sky. Generally the greatest intensity is to the northwest. Also, look directly up. Auroras sometimes occur as an arch from the northwest to the southeast, but they can also appear in any direction.

Try to stay away from city lights, keeping them at distance to provide a warm hue on the horizon line. If I am photographing to the northwest, when

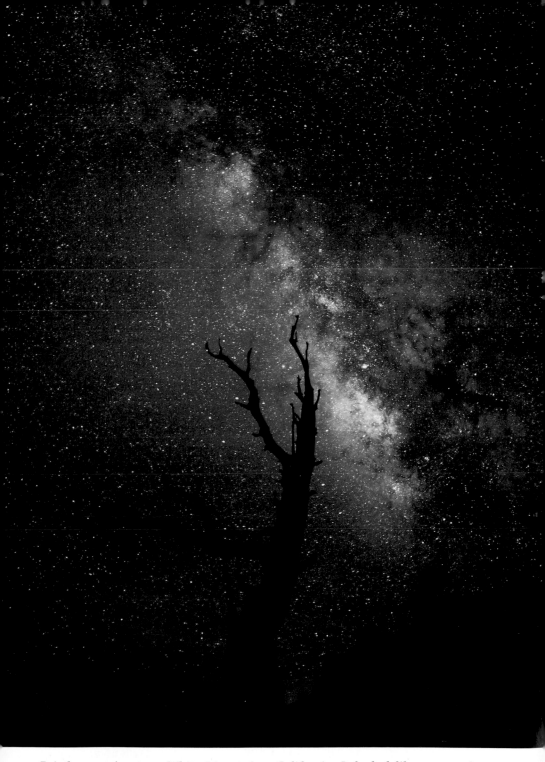

Bristlecone pine tree, White Mountains, California. It looked like a normal night to my eyes, but the camera picked up the colors in the sky. f/1.4, 20 seconds, ISO 2000, 24mm lens, Canon EOS 5D Mark II.

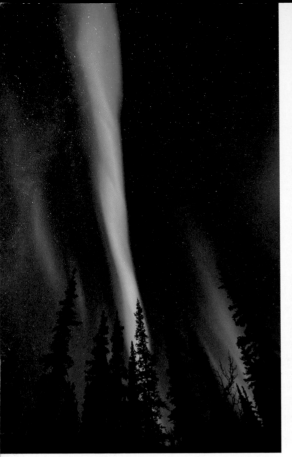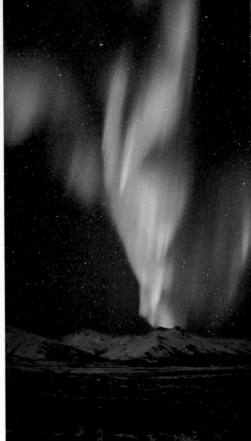

Left: *Aurora with trees. Brooks Range, Alaska. f/2.8, 13 seconds, ISO 1600, 16mm, EF16–35mm f/2.8L II USM, Canon EOS 5D Mark II.* Right: *Northern light in the Brooks Range, Alaska. f/1.4, 10 seconds, ISO 1600, 24mm, Canon EOS 5D Mark II.*

the city lights are nearby, I prefer the city lights behind me, at the southeast, to minimize their impact.

DETERMINING EXPOSURE

For faint auroras, try f/1.4 with a shutter speed of 10 seconds and ISO 400 to 800. At f/2.8 use 13 seconds and ISO 1250 to 2500. Stop down by one stop when possible. When auroras are bright, you will want to recheck the exposure and compensate throughout the night. Note that aurora exposures are three stops smaller than for stars as points of light due to the increased amount of light in the sky. Remember that these recommendations are just starting points, and you will need to adjust the exposure based on how much light is being emitted from the auroras as they change. Check your histogram to make sure you have not blown out the brightest areas, as they can get very bright in spots. Depending on the scene, the histogram may have information in all five of its sections. I use manual meter mode for auroras, but using aperture priority for the changing lighting conditions could work as well.

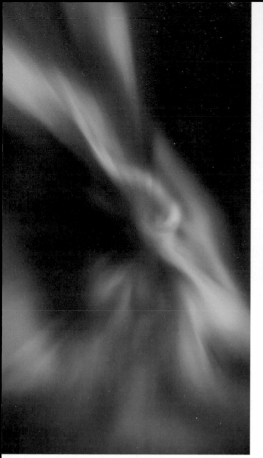
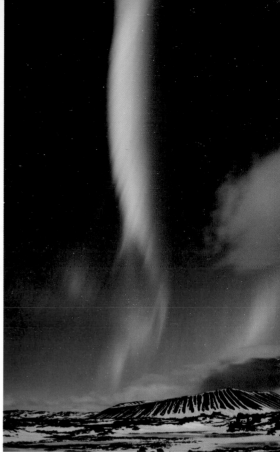

Left: *Looking straight up at an aurora, Mývatn, Iceland. f/4, 13 seconds, ISO 2500, 14mm lens, Canon EOS-1D X.* Right: *Aurora and crater, Mývatn, Iceland. f/2.0, 6 seconds, ISO 1600, EF24mm f/1.4L II USM, Canon EOS 5D Mark III.*

Shutter speeds for auroras vary. If the aurora is not moving too fast, then a 15-second exposure is possible. If the aurora is moving too quickly, try 10 seconds or less—down to 1 second if it is really bright. The faster-moving auroras require faster shutter speeds; otherwise, the image will lose all definition.

If the foreground is too bright from the moon, or too dark, use the black glove technique described in chapter 6, Stars as Points of Light. If the black glove technique won't work because of an uneven skyline, take two photographs: one of the foreground with proper exposure, and another with settings adjusted for the auroras. Combine the two images. See the "Processing Combined Images" section in chapter 11.

If it is a moonless night, incorporating a star trail can be fun. Consider the position of the North Star, as the auroras often appear in the northwest.

It's important to remember to remove all filters, including UV filters, when photographing auroras. Filters can cause ugly rings in the image that are impossible to correct in post-processing.

SHOOTING WITH JENNIFER

Chasing auroras can be an adventure. We researched auroras, looking for a good spot with clear skies by checking the weather forecasts, only to find that our desired location in the south of Iceland was cloudy after all. We drove many hours farther north, where the predictions for clear skies were more favorable. After several nights going out looking for auroras, we were fortunate enough to catch a most spectacular display. I will never forget the incredible feeling of being under the auroras as they danced, at times slowly and at other times moving rapidly—like musical notes playing in every direction in the sky.

Use the same settings as those for photographing stars as points of light. However, try starting out with the Kelvin temperature set to 4400 so as not to change the colors of the auroras too much while still capturing a dark blue sky. Auroras are usually green, which imparts a color cast to the entire image. When processing your images, add magenta (via a tint slider), as needed, to reduce the overpowering green color.

Since aurora photography tends to take place in winter in the northern latitudes, make sure to keep yourself and your camera warm. See the "Field Conditions" section in chapter 3.

VOLCANOES

Photographing volcanoes is a thrilling, awe-inspiring experience. A volcano emits lava, rocks, and gasses, sometimes violently, sometimes not. We can photograph an angry pillar of smoke along with ash lit by lightning bolts or some slow-moving, ropey lava flowing no faster than a lazy stroll. Lava may gush into the sea amid steam and surf or ignite nearby forests.

Safety is important. Make sure the winds are not blowing in your direction, because inhaling sulfur dioxide or hydrochloric acid gasses may do permanent damage to your lungs or kill you on the spot. Don't trust newly formed crust and lava benches near the ocean's edge. You may step right though them, as you would a thin snow bridge over a crevasse. Do some research before you venture out to photograph volcanic activity.

To photograph a volcano, there are several factors to consider when determining the exposure. For a volcano with explosions, the most important factor is the shutter speed, followed by the f-stop. When photographing any situation, decide what is most important—f-stop for depth of field or shutter speed to stop motion—and set that first. Shutter speeds of 5 seconds or longer make volcanic explosions look too misty. Using a faster shutter speed of 2.5 seconds allows for some trails from explosions without too much mist. Increase the ISO when shooting at night to get a fast enough shutter speed; try ISO

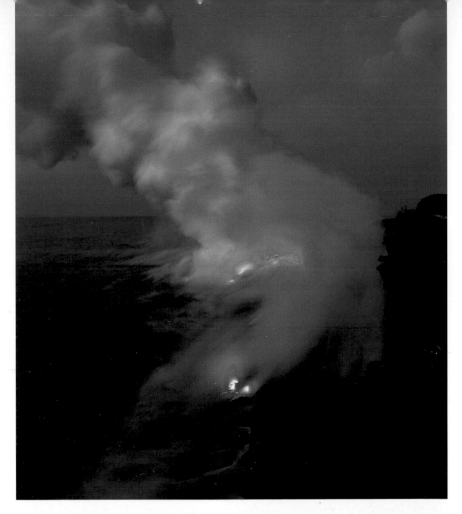

Kilauea, Hawaii, at twilight. f/9, 2 seconds, ISO 100, 16–35mm II lens at 20mm, Canon EOS 5D Mark II.

640. During the day, the red in volcanic explosions is not visible because the sunlight washes it out. The color becomes apparent at twilight. Set the ISO to the camera's native ISO setting. The ambient light at twilight will allow for a sufficiently rapid shutter speed.

When photographing a lava flow, a slower shutter speed adds a bit of motion blur, keeping the flow from appearing crystalline and static. This is similar to photographing a slow-moving stream. A smaller aperture, lower ISO, or both, will allow the use of a slower shutter speed. The shutter speed needed will vary by how fast the flow is moving, with slow-moving flow requiring a slower shutter speed. So review the image on the LCD screen to get a silky look. Another factor to consider is the focal length of the lens. A wide-angle lens will require a long shutter speed as the movement of the flow appears slower within the wide coverage area. A telephoto lens can work with a faster shutter speed because the flow is viewed as moving faster through the frame.

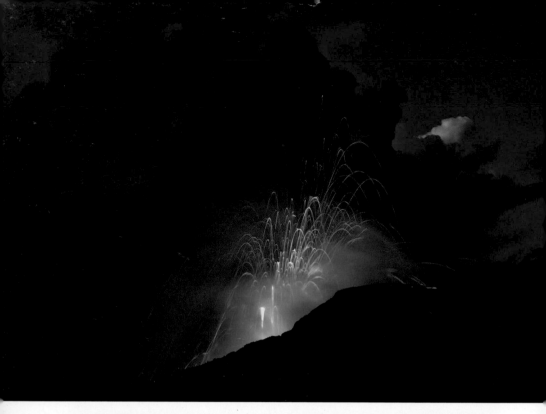

Kilauea, one of the world's most active volcanoes, exposed at f/4.5, 2.5 seconds, ISO 640, 24mm, EF24–70mm f/2.8L USM, Canon EOS 5D Mark II.

Kilauea lava flow. The shutter speed of 0.8 second worked well to show the smooth look of the lava flow. f/20, 0.8 second, ISO 100, Canon EOS 5D Mark II.

Kilauea Caldera at dusk with three-stop graduated neutral density filter. To photograph the Kilauea Caldera at dusk, I used a three-stop hard-edge graduated neutral density filter over the lower part of the image. The dark part of the filter was on the bottom of the frame, covering the bright area of the volcano to balance out the exposure in the sky. f/4.0, 30 seconds, ISO 1000, 24–70mm lens at 24mm, Canon EOS 5D Mark II.

Milky Way, Kilauea Caldera, and Halema'uma'u Crater. I used three- and two-stop hard-edge graduated neutral density filters over the bottom to hold detail in the crater's edge, but it was not enough for the volcanic activity. f/2.0, 20 seconds, ISO 3200, EF24mm f/1.4L II USM, Canon EOS 5D Mark II.

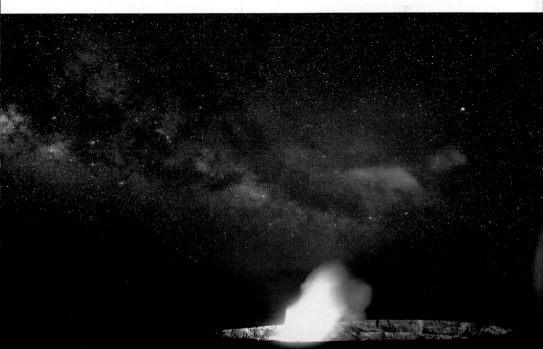

11

POST-PROCESSING
NIGHT IMAGES

Opposite: *Moon, stars, and volcano at the Big Island of Hawaii. f/3.5, 6 seconds, ISO 3200, EF16-35mm II at 16mm, Canon EOS-1Ds Mark III.*

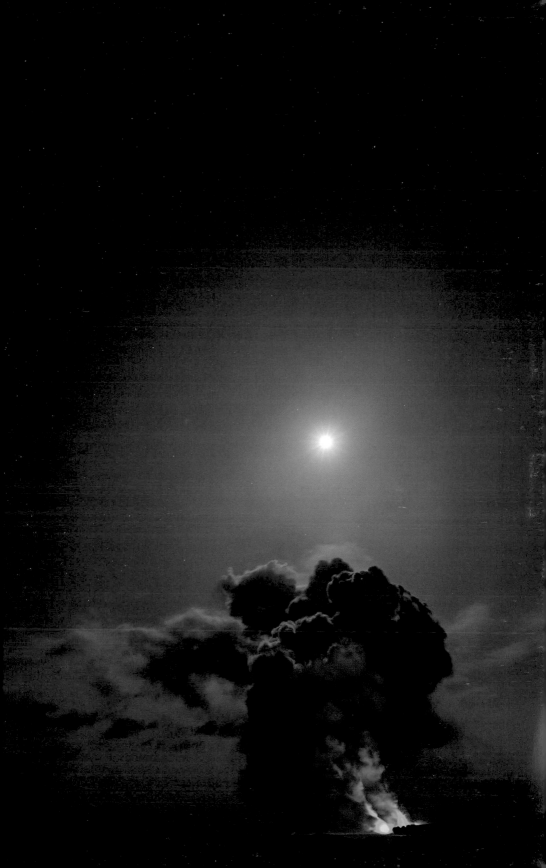

Now that you have taken your photographs of the night sky, you have the raw materials for the next stage in producing night sky images: processing. The following sections take you through the steps of adjusting contrast, saturation, vibrance, and other settings; reducing distortions and noise in your images; and combining images to create composites that showcase the effects of light-painting and multiple-exposure techniques. Processing stars as points of light is presented first, and the section discusses how to make basic adjustments to your RAW files that will be useful for processing all types of images. Converting your files to JPEGs, TIFFs, or PSDs is another key section, as you'll need that information for combining images. While processing images can involve a lot of technical information, it's essentially a creative and playful process. It's where the work you did in the field coalesces into the imagery that originally inspired you.

PROCESSING STARS AS POINTS OF LIGHT

Interpreting a digital image is a matter of taste and artistic sensibility, part of your creative process. I follow these steps to produce a cooler color impression of the night sky. I encourage you to play with the color temperature, contrast, or any other adjustment that creates the look that matches your vision.

These steps apply to Adobe Camera RAW, the RAW editor in Photoshop CS6. Adobe Lightroom 5 employs almost identical tools without going through Adobe Bridge. Other RAW editors such as Apple's Aperture, Capture One, and DxO offer similar tools.

1. Double-click on the image in Bridge to open it in Adobe Camera RAW.
2. Move sliders in the Basic tab to optimize exposure.
 - Move the Temperature slider and Tint slider until you get a color you like. Try 3000 to 4000 K. Or, you might like a warm tone at 6500 K.
 - Increase contrast as desired.
 - Increase or decrease exposure with the Exposure slider so that the image looks properly exposed to the desired brightness. Take care in increasing brightness as it creates noise, and avoid clipping the blacks and highlights. If the histogram touches the left (black) or right (white) edge of its boundaries, it stops recording changes in tone beyond that point, rendering everything beyond as pure black or pure white, that is, "clipping." If the image is a silhouette, there will be clipping in the blacks.
 - To add edge definition, move the Clarity slider to the right, if you're using noise reduction in Photoshop or Lightroom. Clarity significantly increases the intensity of the stars and makes dimmer stars stand out. Watch the stars pop as you move the slider to the right. If using third-party noise-reduction software, leave the Clarity slider at 0.
 - Adjust the Vibrance and Saturation sliders as desired.

The original image without any settings applied.

After the Basic tab settings were applied. The settings used for this image were: Temperature: 3000; Tint: +7; Contrast: +17; Whites: +10; Clarity: +15; Vibrance: +15; Saturation: + 3. All other sliders were left at the default setting of 0.

3. Click on the Details tab.

 ■ View at 100 percent or greater zoom. The noise reduction and sharpening cannot be seen at less than 100 percent.

 ■ In the Noise Reduction section, use the Luminance and Luminance Detail sliders to reduce luminance noise until the grain-like dots are reduced, but not so much that the image gets too soft. The higher the number, the smaller the dots and the fewer the stars as the dimmer ones become fainter. It is a trade-off. The maximum I use is 35–45 points on Luminance and Luminance Detail. For older versions, CS5 and Lightroom 3, use settings up to 50. Any higher than that and the image becomes too soft. If you see color noise (colorful dots in the image) move the Color slider up until you see it reduced.

 ■ Leave the sharpening settings at their defaults for the Amount, Radius, and Detail sliders. This works well, but you can also slightly increase the Amount and Detail if you wish. Do sharpening after noise reduction.

 ■ Under Sharpening>Apply Masking, you can gain smoother sky tones by increasing the masking, which prevents smooth areas such as silky water or skies from being sharpened. When the smooth area of the sky is sharpened, it adds unwanted noise. Hold the Option key on a Mac or the Alt key on a PC and move the Masking slider to the right, with Amount set higher than zero (by default it is set to 25). As the slider moves, a white overlay shrinks to a pattern aligned with the image's edges. White indicates what will be sharpened, and black shows the areas where sharpening won't occur. To sharpen stars, move the slider to the right until you still see the stars as white dots while most of the sky becomes dark. This way, the stars will be sharpened while the sky doesn't become grainy from the noise being sharpened.

4. Click on the Lens Correction tab.

 ■ Within Lens Correction, click on the Profile tab. Be sure "Enable Lens Profile Corrections" is not selected, otherwise it will lighten the image too much resulting in additional noise.

 ■ Within Lens Correction, click on the Color tab, then click on View at 100 percent.

 a. Check the box that reads "Remove Chromatic Aberration." Click the Preview checkbox at the top of the screen to see the effects and look at the corners.

 b. I leave the Defringe sliders alone because they produce a dark halo around other stars.

 ■ Within Lens Correction, click on the Manual tab. Under Lens Vignetting, to equalize the exposure between the edges and the center, move the Amount and Midpoint sliders to the right, lightening the corners to match the rest of the image. The amounts will vary depending on your lens and aperture setting.

Without noise reduction applied.

With noise reduction applied. Notice smoother tones in the sky and reduced color and light noise, the digital equivalent of film grain.

Masking applied while holding down the Alt or Option key.

5. Save your settings (optional). You can save your settings so you can apply these steps to an image all at once.
 ■ Go to the Basic tab.
 ■ Click on the Camera RAW Settings menu, the little black triangle on the right.
 ■ Choose Save Settings.
 ■ Give your settings a name, such as Star Settings. Save.
 ■ You now have a macro for applying the settings to any image.
 ■ To load all these settings at once to a new image:
 a. Find the Camera RAW Settings menu by clicking the little black triangle on the right side of the Basics bar. This opens the RAW settings menu. Select Load.
 b. Another way to apply the settings is from Bridge. Right-click on the image in Bridge, choose Develop Settings, and select the saved file.
6. Click on Open Image or Done.

PROCESSING STAR TRAILS

There are several methods for processing star trails. Methods in Photoshop and Lightroom will be covered in this section. Additional information and several software sources for stacking star trails can be found in the Resources, including some that are free. Startrails (www.startrails.de/html/software.html) is a good one if you are using Windows. Single-exposure star trail images can be processed using the same settings as used for processing stars as points

of light. Multiple-exposure images will need to be combined in a multistep process that typically includes converting your images from RAW to JPEG file formats and using Photoshop by itself or in concert with scripts. The No Gap Method uses a script by Floris Van Breugel, and the Stack-A-Matic method uses a script from Russell Brown.

TIP

Sometimes you'll end up with streaks of light from planes in your star trails images. If you want to be fastidious, go into Photoshop and lasso the streaks with the Patch tool. For star trails, this means working one frame at a time if you are stacking multiple images.
Here's how:

1. First, create a new layer (Command+J on a Mac, Ctrl+J on a PC) and work on the new layer so you can try again if you mess up the image; you'll still have the original layer.
2. Activate the Patch tool.
3. Zoom to 100 percent or larger, and lasso the offending streaks between major stars. If you need to remove a small tail on a star, switch to the Clone tool to erase it.

FILE FORMAT CONVERSIONS: JPEG, PSD, OR TIFF

Make JPEG, PSD, or TIFF images from your RAW files to stack the images together in Photoshop. How you process your images will depend on how much RAM you have in your computer. If you have just a few files, then full resolution TIFF or PSD should be fine; otherwise use compressed JPEG files. If your computer is not able to process all the JPEG files, then try reducing file size or including fewer images, as JPEGs will process faster than TIFF files.

1. Process the RAW files. Use the same settings as for stars as points of light. See "Processing Stars as Points of Light" above.
 - Choose images that are in continuous sequence and without plane lights or distracting car headlights, assuming you have plenty of images to put together.
 - Do not make Smart Objects. The default is with this feature turned off, so you don't need to do anything unless you have previously set your processor to open images as Smart Objects. If so, click on the blue text that looks like a hyperlink at the bottom of the page. Make sure there is no check mark next to "Open in Photoshop as Smart Objects." You do not need to worry about this if you are using Lightroom to process your images.
2. Convert the RAW files into full-size JPEG images to save computer time assembling the files. Using either Adobe Bridge or Lightroom software, select the images you wish to convert to JPEGs by clicking on the images one at a time while holding down the Command key on a Mac or Ctrl on a PC. If all the images you want are in an unbroken

Click on the text at the bottom of the screen for additional choices, and select 8-bit if you want to keep files small.

sequence, select the first image in the sequence, hold down the Shift key, and click on the final image. The entire sequence will be selected.

■ In Bridge, select Tools > Photoshop > Image Processor.

■ In the Image Processor dialog box, use the following settings (see illustration):

 a. Check "Save in Same Location" (radio button)

 b. Under File Type, check the "Save as JPEG" box. (You can use TIFF files if you have only a few files and plenty of processing power.)

 c. Type "12" in the box labeled Quality.

 d. Check the "Include ICC Profile" box.

 e. Click Run.

■ In Lightroom, select File > Export, or click the Library Module and click on Export.

 a. In the Export To drop-down menu, select "Same folder as original photo." This will place your files within a JPEG folder in your original folder.

 b. From the Image Format drop-down menu, select JPEG.

 c. From the Color Space drop-down menu select Adobe RBG or whatever you normally use.

 d. In the Image Sizing section, uncheck Resize to Fit.

 e. Click Export.

Bridge image processor.

Export for JPEG in Lightroom.

THE PHOTOSHOP METHOD

Note that this method for stacking star trails leaves little gaps when used with wide-angle images. See the No-Gap Method in the next section if you've used a wide-angle lens.

1. In Bridge, select the JPEG images you want to include in the star trails.
2. From the menu bar choose Tools > Photoshop > Load Files into Photoshop Layers.
3. Click on the top layer to select it, press and hold the Shift key, then click on the bottom layer. This will select all of the layers.
4. With all layers still selected, change the Blend mode from Normal to Lighten from the drop-down box; it will change all the layers at once. In older versions of Photoshop, you may need to change the Blend mode to Lighten for each layer individually.
5. Flatten the file. From the menu bar select Layer > Flatten Image.
6. Save the file as a TIFF or PSD file.

THE NO-GAP METHOD

Use this method to eliminate gaps in the star trails that result from using wide-angle lenses.

1. First, process your RAW images to leave most of the settings to their default of 0 including the Exposure, Contrast, Shadows, Whites, Blacks, and Clarity sliders. Do not sharpen more than the default setting in the processor. Do not darken your image in Adobe Camera RAW. You

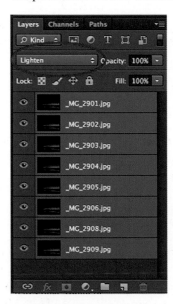

Changing Blend mode. *Example of layers in Photoshop.*

might think to do this to have proper exposure in the final image; however, it will result in reduced contrast and color. Process the final image after you combine images together, rather than before, for best results.

- In processing the RAW file, you can adjust the Vibrance, Saturation, Noise Reduction, and White Balance controls as desired.
- Check the box for Chromatic Aberration found in the Lens Corrections tab. I suggest using the auto setting for Chromatic Aberration because the manual method results in additional chromatic aberrations on other stars. Be sure to check the corners of the image to make sure that it has not lightened too much and check for increased noise in the lightened areas.

2. Create TIFF or JPEG files of the star trail images. Keep them in a separate folder and in order. See instructions, above, on creating JPEGs.
3. Download the following file by Floris Van Breugel: www.artinnaturephotography.com/page/startrailstacker/. It is a script to put together the star trail images.
4. Locate the file you just downloaded. Click on the file named "star _trail_stacker_by_floris_v0.21_flat." There are two files, one that leaves all your stacked images as a flattened file and one that leaves all of the layers. We do not need the layers and they make the file larger, so use the file that ends in "flat."
5. When the dialog box appears that asks whether you want to run the script, click Yes.
6. Select your folder with the JPEG or TIFF images. Click Open. Your stacked images will open in Photoshop.
7. The final image will be about one stop too light, it will lack contrast, and it will look dull. Process the image in Photoshop to make it look as you would like it, adjusting Contrast, Vibrance, and Darkening. We don't cover basic Photoshop processing here, but there are many free training videos on the adobe.com website.
8. Save as a TIFF or PSD file.

To perform the same operation manually—without the script—do the following:

1. Do steps 1 and 2 in the above No-Gap Method (skip steps 3-6).
2. Open Adobe Bridge, and select the images you want to include in the star trails.
3. From the menu bar, choose Tools > Photoshop > Load Files into Photoshop Layers
4. Make a duplicate layer of each layer except the top and bottom layers by clicking on the layer and pressing Command+J (Mac) or Ctrl+J (PC).
 - For example you will start with Layer 1 (background layer), Layer 2, Layer 3, Layer 4, Layer 5, Layer 6 (top layer in this example). After this step you will have Layer 1 (background layer), Layer 2,

 Layer 2 copy, Layer 3, Layer 3 copy, Layer 4, Layer 4 copy, Layer 5, Layer 5 copy, and Layer 6 (top layer).

5. In the Layers panel, you will see the names of Layer 1, Layer 2, Layer 2 copy, etc. Click on Layer 2 (not Layer 2 copy), which will highlight it, and change the Blend mode to Screen. Click on the drop-down menu under Normal and select Screen.

6. Now you are going to begin merging layers. Select Layer 2 then press and hold the Shift key and click and release the mouse on the layer below (in this case Layer 1). This will highlight both layers. Now with two layers selected, press Command+E (Mac) or Ctrl+E (PC), which merges the layers. Set the Blend mode on this new layer to Lighten. You can do this by going to the Layers panel and clicking on the drop-down menu under Normal and selecting Lighten.

7. Now select Layer 2 copy and Layer 3 and repeat the process from Step 6 of merging the layers and setting the Blend mode to Lighten. Repeat with the remaining layer pairs (Layer 3 copy and Layer 4, Layer 4 copy and Layer 5, Layer 5 copy and Layer 6).

8. When you are finished with the layers, flatten the image by choosing Layer and Flatten Image from the menu bar.

9. The final image will be about one stop too light, it will lack contrast, and it will look dull. Process the image in Photoshop to make it look as you would like it.

10. Save as a TIFF or PSD file.

THE STACK-A-MATIC METHOD

Star trails with a single exposure can be created in Photoshop. Use this link: russellbrown.com/scripts.html, read the directions at the top of the page, scroll down, and download this file: "CS6 Script: Stacking Multiple Images with Dr. Brown's Stack-A-Matic 2.3.1." See "Composites from Separate Images," below, for refining the final star trail image.

PROCESSING COMBINED IMAGES

Beyond stacking images for star trails, there are many situations where you may want to join your photographs together. Four techniques are covered below, each with unique advantages and purposes. Whether you want to print panoramas, blend light-painted images together, or create fantastical composites, I encourage you to view these methods as simply starting points for your creative experiments.

PHOTOMERGE FOR PANORAMAS

Photomerge is a command in Photoshop that stitches several images together. It performs many steps automatically and will yield good results if you take care while capturing the image.

1. Reach Photomerge under File > Automate > Photomerge.

2. Choose Auto Layout. If Auto Layout doesn't look good then try choosing Reposition and see if it does a better job.

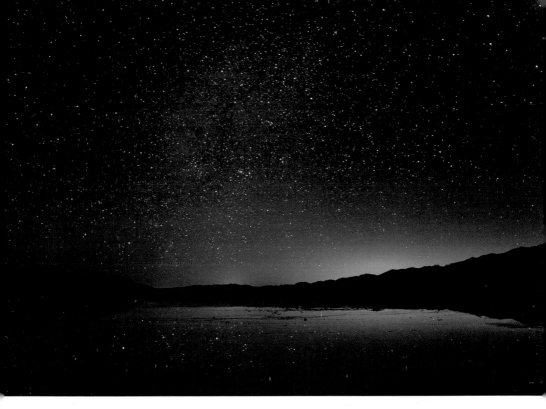

This is a single image of the stars in Death Valley National Park, California, at f/1.4, 20 seconds, ISO 2000, Canon EOS 5D Mark II.

This is the same image using Dr. Brown's Stack-A-Matic.

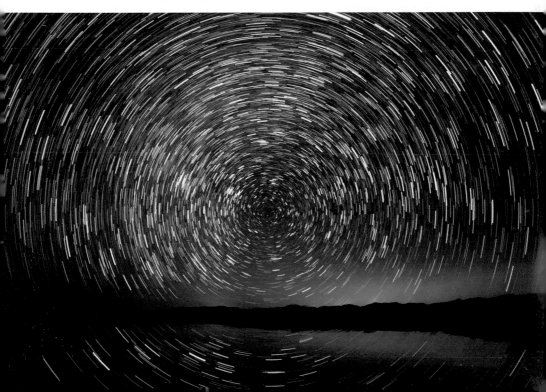

3. Click Browse, find the images you wish to merge, and select them.
4. Check "Blend Images Together" and "Vignette Removal."
5. Click OK. If you shot with enough overlap, Photomerge opens, tiles, merges, and displays the new panorama.
6. At this point, the panorama will have irregular borders. Create the largest possible rectangle by selecting the Crop tool ("C" on your keyboard), and cropping out empty space by dragging the tool across the image. If you don't like your first cropping attempt, click Esc to cancel. Once you're satisfied, hit Return (Enter on a PC) to complete the crop. This will cut some of the image, leaving a clean panorama.

LAYER MASK TECHNIQUE FOR LIGHT-PAINTED PHOTOGRAPHS

This method, using a layer mask, was used for combining a light foreground and dark stars for the image at Cathedral Lakes and for the stars in the ice cave in Iceland (see "Combining Images" in chapter 1). Use this method when combining two star images with different exposures, when combining an image focused on the foreground and one on the background, or when you want to use a layer mask in the Stack-A-Matic method for star trails to hide the foreground, which can become blurry on the edges.

1. Process the RAW files. Use the same settings as for stars as points of light.
2. Open Adobe Bridge and select the images you want to use.
3. From the menu bar choose Tools > Photoshop > Load Files into Photoshop Layers.
4. Click on the top layer in the Layers panel (it should be there by default). The layer you are on will be highlighted in blue. If you can't see the Layers panel, go to the menu bar, choose Windows, and select Layers. There will be a checkmark next to each window that is visible.
5. Press and hold the Alt key on a PC or the Option key on a Mac and click on the Add Layer Mask icon at the bottom of the Layers panel. This will add a layer mask and fill it with black. Do this for each layer except the background.
6. The black layer mask we just created hides the effect of that layer so we only see the background layer below. In Photoshop, white reveals and black hides. So with black activated, the effect is hidden. Now we want to show the red-painted tree, but not the foreground that has too much red light on it.
7. Select the Brush tool. Press the D key to get the default colors. Press the X key to toggle back and forth from black to white for the foreground color (that is, the color of the top box). Set the foreground color to white. See the image next page, right, for the Brush tool and foreground/background color picker.
8. Set the Brush tool to the desired size and softness. In the Brush tool menu bar, I set the flow to about 20 percent but use whatever setting

Above: *Add Layer Mask icon.*

Right: *Brush tool and foreground/background color picker.*

you desire. Lowering either the fill or the opacity will lessen the effect of the painting with white, and you can keep painting over it until you have your desired effect.

9. Paint with white on the areas where you want the light-painting to show through. If you make a mistake and paint too much, press the X key to toggle back to black for the foreground color and paint with black.

10. Continue painting until all areas are painted in.

11. If you have more layers, click on each layer and paint in as desired.

12. Save the file as a TIFF or PSD file.

I use a soft edge brush set to 125 size with Flow at 20 percent.

Original image has light on the foreground that I did not want to include.

Final image does not have light on foreground in lower right corner.

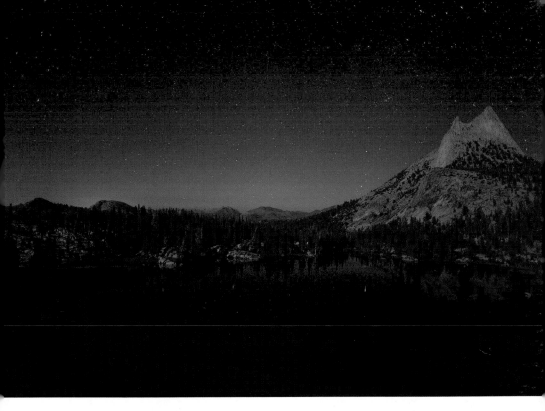

This image was exposed for the sky, but the foreground is too dark.

This image was exposed for the foreground, but the sky is too bright.

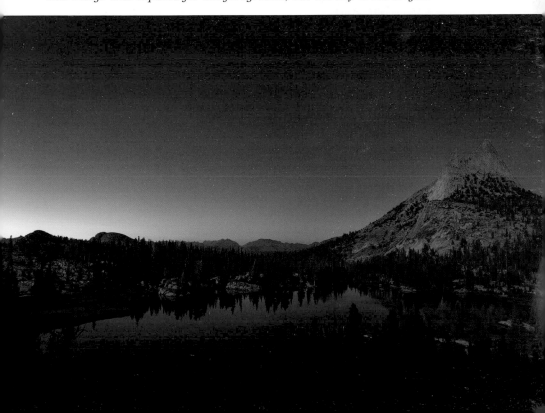

Layer mask used to reveal the dark sky with the light foreground. Pressing and holding the Alt key on a PC or the Option key on a Mac and clicking on the layer mask will reveal it in the preview window.

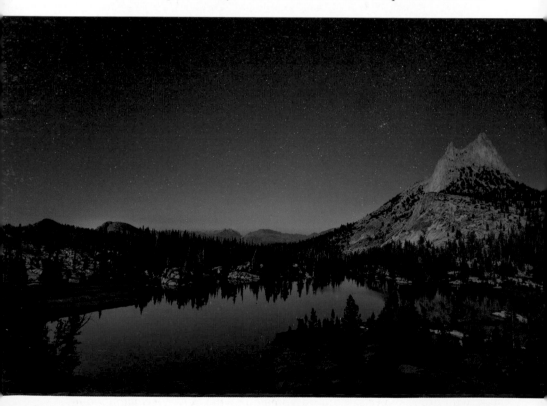

Here both images were combined and a layer mask was used to block the dark foreground by painting the sky with a white paint brush on the black layer mask.

Changing the Blend mode to Screen.

BLEND MODE CHANGES FOR COMPOSITES

Process the RAW files. Use the same settings as for stars as points of light.
In Photoshop, open Adobe Bridge and select the images you want to use.

1. From the menu bar choose Tools > Photoshop > Load Files into Photo-shop Layers.
2. In the Layers panel, you can select the layer and change the mode from Normal to Screen. This allows the black to become transparent to show the lighter values of the images only coming though. If you can't see the Layers panel go to Windows > Layers.
3. Try using the Lighten setting in Blend more, or experiment with other Blend mode settings, for different effects.

For an example of the effect of using Screen Blend mode, see the "Combining Images" section in chapter 1 for a photograph of a waterfall (Seljalandsfoss) and stars.

COMPOSITES FROM SEPARATE IMAGES

There are many uses for combining star images. The image in the "Combining Images" section of Chapter 1 of the ice cave with stars in the sky instead of a white sky used this method. It is one example of how you can let your creative juices flow as you come up with ways of combining stars with other subjects. I can only imagine what Jerry Uelsmann would do with stars! Check out his images for inspiration on making composites (www.uelsmann.net/).

For your first attempts, start with two images to combine and add more as you get better at combining the images. Look for two images you would like to put together, such as a landscape by twilight and an image of the stars in the sky. Star images may combine well with trees, buildings, or other features of the landscape. There are so many ways to be creative with this, and I encourage you to experiment and keep learning.

1. Process the RAW files. See "Processing Stars as Points of Light" for settings to use.
 - If you did star trails with multiple exposures, combine those images first and make a new file.
 - If you have multiple foreground images, you can select them in Adobe Bridge. Combine those first. Choose Tools > Photoshop > Load Files into Photoshop Layers. In Lightroom choose Edit In > Open as Layers in Photoshop.

2. In the Layers panel, hold the Shift key, select all the layers, and then click on the Opacity slider and lower it as you would like or adjust any layers individually. Save the foreground file.

3. In Adobe Bridge, select the foreground and background photographs you want to combine. Select the first image, press and hold the Ctrl key on PC or the Command key on a Mac, and click on the additional image or images you want to include, such as a foreground image and night star image. The foreground layer is best as the first selection, or bottom layer, and the stars as the top layer.

4. From the menu bar choose Tools > Photoshop > Load Files into Photoshop Layers. This will load all the files into one layer in Photoshop.

5. In the Layers panel, you can select the layer and change the mode from Normal to Screen. This allows the black to become transparent to allow only the lighter values of the images to come though. If you can't see the Layers panel go to Windows > Layers.

6. In the Layers panel, click on the Add a Layer Style icon at the bottom of the panel and choose Blending Options, the first choice. This brings up the Blending Options dialog box.

7. At the bottom, under Underlying Layer, click on the black triangle slider and slide it to the right to reveal the foreground or bottom layer. Move the slider to the right until you see the amount of the foreground layer you want. Next separate the slider to further reduce the effect of the top layer to blend it more into the bottom layer. Hold the Alt key on PC or the Option key on a Mac and click on the right side of the black triangle. This will separate the sliders and make the transition of the layers softer. Move the slider to the right where it looks good. Click OK. You can make changes anytime by clicking on the layer and the *fx* icon (it looks like two square boxes on that layer) to bring up Blending Options again and move the sliders where you want.

8. Alternatively, skip steps 6 and 7. In the Layers panel, click on Add Layer Mask.
 - Select the Brush tool, press the B key. Set your foreground and background colors to the default by pressing D. Then you can press the X key to toggle back and forth between white and black. Paint with black to reveal the layer underneath. I set the opacity at 100 percent for this and use a soft-edge brush, a setting of the Brush tool.
 - White shows and black hides the image on the top. Paint with white in any areas where you went too far with the black.
9. The edges of the star trails can get stretched out, so I crop a little of that out.
10. Save your new star trails file.

A FINAL NOTE OF ENCOURAGEMENT

The possibilities of photographing the night sky are as endless as the sky itself. With the capabilities of modern digital cameras and the tools of the digital darkroom, we can capture ephemeral moments, craft a personal vision of the universe, and portray a glimmer of its immensity in our art.

We hope you will use this guide to hone your techniques for capturing the stars as points of light, creating star trail images, and using light in all its forms, whether from a sliver of moon, the last rays of the setting sun, or the glow of an aurora. Our aim is to inspire you to use your new knowledge to shoot the stars and the moon in all kinds of settings and to give you new ways to think about composition.

Contact us through our websites if you wish to share your creative views of the cosmos or your thoughts about the book and night photography. We look forward to seeing your unique takes on the night sky. Happy photographing.

Next page: Bristlecone pine tree in the White Mountains, California. Light pairing with household flashlight diffused with an air sickness bag from about 10 feet to the right of the camera and tree. f/1.8, 20 seconds, ISO 3200, 24mm lens, Canon EOS 5D Mark III.

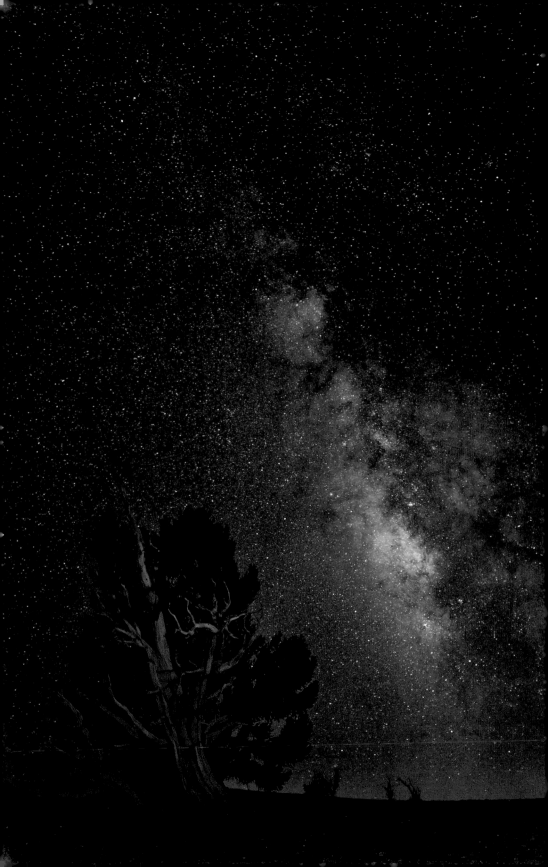

RESOURCES

Check out additional night photography images and blog posts and share your images or your thoughts about this book and night photography at:
Jennifer Wu: www.jenniferwu.com.
James Martin: www.jamesbmartin.com.

AURORAS
App (iPhone): Aurora Forecast
Astronomy North: www.gi.alaska.edu/AuroraForecast
Geophysical Institute Aurora Forecast: www.gedds.alaska.edu
 /AuroraForecast/
National Oceanic and Atmospheric Administration (NOAA):
 OVATION Auroral Forecast (NOAA): http://helios.swpc.noaa.gov/ovation/
 Polar-orbiting Operational Environmental Satellite (POES): www.swpc
 .noaa.gov/pmap/index.html
 Space Weather: www.swpc.noaa.gov/today.html
Spaceweather.com: www.spaceweather.com

CAMERA OPERATIONS AND HYPERFOCAL FOCUSING
Canon Digital Learning Center: www.usa.canon.com/dlc/
Hyperfocal Focusing: dofmaster.com
Jennifer Wu's blog post "Hyperfocal Focusing," at www.jenniferwu.com
 /hyperfocal-focusing/ has a handout with how-to and a chart to help
 you get as much in focus as possible.
Lens Angle of View Calculator: www.sweeting.org/mark/lenses/canon.php

DARK SKIES
Dark Sky Finder: www.jshine.net/astronomy/dark_sky/
International Dark-Sky Association (IDA): www.darksky.org
The Night Sky in the World: www.lightpollution.it/dmsp/

ECLIPSES AND NOCTILUCENT CLOUDS
National Aeronautics and Space Administration (NASA) Eclipse Website:
 eclipse.gsfc.nasa.gov/lunar.html
National Aeronautics and Space Administration (NASA), Science News,
 "Strange Clouds" article on noctilucent clouds: science.nasa.gov
 /science-news/science-at-nasa/2003/19feb_nlc/

IRIDIUM FLARES
Apps: Sputnik! (Android), Heavens Above, Iridium Flares
Heavens Above: www.heavens-above.com

Mac Widget: www.dashboardwidgets.com/showcase/details.php?wid=1411
Visual Satellite Observer: www.satobs.org/iridium.html

METEORS
StarDate: stardate.org/nightsky/meteors

STAR TRAIL STACKING SOFTWARE
Art in Nature Photography: www.artinnaturephotography.com/page/star-trailstacker/. Discusses how to reduce gaps in stacked star trails.
Dr. Brown's Stack-A-Matic 2.3.1: russellbrown.com/scripts.html
Image Stacker: www.tawbaware.com/imgstack.htm
Images Plus: www.mlunsold.com. Works with RAW files. Watch tutorials.
Star Trails Photoshop Action: www.schursastrophotography.com/software/photoshop/startrails.html
StarStaX: www.markus-enzweiler.de/software/ware.html
Startrails: www.startrails.de/html/software.html. You can use a dark frame to help reduce noise with this program. Windows OS only.

STARS AND MILKY WAY
Apps: Star Walk, Heavens Above
Moravian College Astronomy: www.astronomy.org
Starry Nights Software: www.starrynighteducation.com. I use Starry Night Enthusiast for the path of sun, moon, Milky Way, and more.
Stellarium: www.stellarium.org. Free desktop planetarium software, shows the path of the Milky Way.

SUN AND MOON
Apps: Sun Seeker, Sky Safari, LightTrac, Photographer's Ephemeris
Golden Hour: www.golden-hour.com
Naval Oceanography Portal: www.usno.navy.mil/USNO/astronomical-applications
The Old Farmer's Almanac: www.almanac.com/astronomy and www.almanac.com/weather
The Photographer's Ephemeris: photoephemeris.com.
The Sun/Moon Calculator: www.largeformatphotography.info/sunmooncalc/
Sunrise and Sunset Times: www.timeanddate.com
SunriseSunset: www.sunrisesunset.com
Yosemite Moonbow: uweb.txstate.edu/~do01/moonbows2010.html

WEATHER
7Timer!: 7timer.y234.cn. Web-based meteorological forecasts.
Clear Sky Chart: cleardarksky.com/csk/. Astronomer's forecasts.
Spaceweather.com: www.spaceweather.com. Sun-earth events and forecasts.
Weather Underground: www.wunderground.com

GLOSSARY

500 rule: A rule of thumb for determining the minimum shutter speed for stopping star motion: divide 500 by focal length to get the shutter speed in seconds.

angle of view: The arc of degrees covered by a given focal length and sensor size.

aperture: The diameter of the opening within the lens that allows light to reach the sensor.

aurora: Colorful atmospheric lights cause by energetic particles affected by the earth's magnetic field at the poles.

barrel distortion: Straight lines bowed in from the edge of the frame, found in photos taken with wide-angle lenses.

Belt of Venus: A band of pink light that appears briefly after sunset and before dawn.

blue hour: Twilight—the time just after the sun has set or just before it rises, when there is some light in the sky.

candle power: A unit of measure of luminance intensity, now known as "candela."

color temperature: A description of the color of a light source, usually measured in degrees Kelvin. Daylight is 5500 K.

coma: Lens aberration that causes off-axis distortion seen as lines or blobs in the corners of images. Most common in wide-angle lenses.

crop sensor: Any sensor covering less area than 35mm film; a full-frame sensor is one that covers the same area as 35mm film.

DSLR: Digital single-lens reflex—a type of camera that allows viewing through the lens via a mirror.

earthshine: Sunlight reflected from the earth to the moon, brightening the part of the moon that is in shadow.

effective focal length: The focal length of a lens that would produce the same angle of view if used on a full-size sensor.

expose to the right: Overexposing without clipping highlights to capture more tonal gradations on a digital sensor.

false dawn: *See* zodiacal light.

f-stop: A measure of the size of the lens opening that refers to the ratio between the focal length and opening.

gel: A colored sheet of flexible plastic used to change the color temperature of a light source.

gibbous: The phases of the moon between half and full.

graduated neutral density filter: A filter that is dark on top and light on bottom. It is generally used to balance exposure from the sky to the foreground so that the sky doesn't wash out. Available in hard- and soft-edge gradients and different f-stop densities. A hard-edge filter means that it

has a hard line gradation and a soft-edge filter has a gradual transition from dark to light. A one-stop filter means that there is one stop of light difference between the top and bottom parts of the filter.

histogram: A graphic representation of tonal values of a photograph as a bar chart.

intervalometer: A device for programming exposure duration and intervals between shots.

ISO: A measure of sensitivity to light.

LCD: Liquid crystal display; a screen on a camera for viewing images and menus.

LED: Light-emitting diode; a small, efficient light source.

light pollution: Light in the atmosphere created by particles reflecting ground-based light sources, e.g., city lights.

meteor: The bright tail of a falling meteoroid; it formerly referred to the meteoroid as well.

meteoroid: A small bit of rock and ice orbiting the sun that falls to earth.

mirror-less camera: A camera using an electronic viewfinder instead of an optical viewfinder.

neutral density filter: A solid filter with no gradation. It comes in different f-stop densities and is available as variable neutral density filters that can change the amount of darkness with rotation of the filter.

new moon: The day the moon is closest to the sun in the sky and is therefore invisible.

RAW: The file format from a camera image containing all the information captured by the sensor, including metadata.

reciprocity failure: Film's exponentially diminishing response to low light levels during long exposures, which leads to color shifts.

script: A sequence of commands that perform a complex function with a single command. Similar to an "action" in Photoshop.

sensor: A digital sensor takes the place of film emulsion, converting an optical image to an electrical signal that is decoded in software.

starburst: A starburst effect derived from diffraction caused by a small aperture.

star trail: Either a single long exposure, or a series of exposures, that records the transit of stars over time, showing them as curved or straight lines instead of points of light.

strobe: A flash often used with DSLR cameras.

time-lapse: A photographic technique in which a series of consecutive photographs is assembled as a movie.

tungsten: An incandescent light bulb or lamp that produces a warm color temperature. Used for light-painting.

white balance: A camera setting for color temperature.

zodiacal light: A colorless glow on the horizon generated by a thin cloud of dust in space positioned along the ecliptic; most easily seen before dawn and after dusk near the equinoxes.

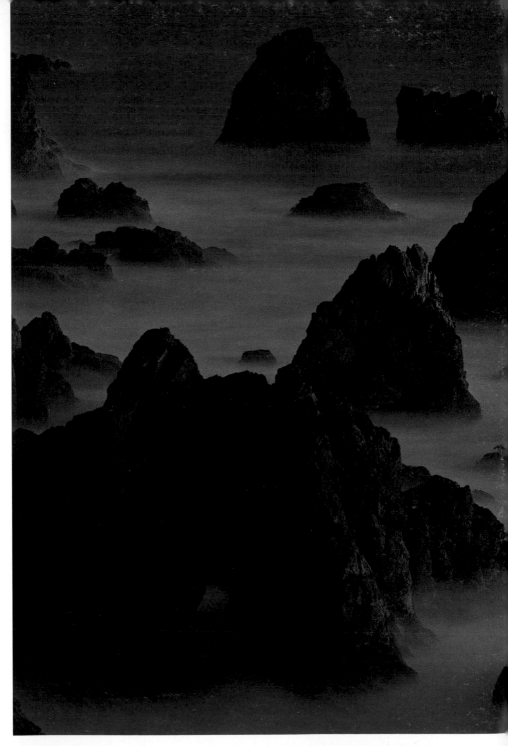

A close up of sea stacks at twilight just before it became too dark to see at all, Bodega Bay, California. f/6.3, 30 seconds, ISO 100, EF100-400mm at 135mm, Canon EOS-1Ds Mark III.

ACKNOWLEDGMENTS

I want to thank Canon USA for their sponsorship and for selecting me to join their Explorers of Light program. I am grateful for the experience with Canon and very honored to be a part of the program.

All of the photographs in this book were shot with Canon equipment. Photographs used in this book were taken over a span of many years, and cameras and lenses varied.

Cameras include:
Canon EOS-1D X
Canon EOS-1Ds Mark III
Canon EOS 5D Mark III
Canon EOS 5D Mark II
Canon EOS 5D Mark I
Canon EOS 7D
Lenses include:
EF 8–15mm f/4L Fisheye USM
EF 14mm f/2.8L USM
EF 14mm f/2.8L II USM
EF 15mm f/2.8 Fisheye
EF 16–35mm f/2.8L II USM
TS-E 17mm f/4L
EF 24mm f/1.4L II USM
EF 24–70mm f/2.8L USM
EF 70–200mm f/2.8L IS II USM
EF 70–200mm f/2.8L IS USM
EF 100–400mm f/4.5–5.6L IS USM
EF 300mm f/2.8L IS USM +1.4x
EF 400mm f/4 DO IS USM +1.4x
EF 800mm f/5.6L IS USM +2.0x

Jennifer Wu

INDEX

ABOUT THE AUTHORS

JENNIFER WU

Jennifer Wu is a nature and landscape photographer specializing in night photography. Canon named Jennifer as an Explorer of Light for her night photography. The Explorers of Light are a group of internationally recognized, elite photographers. Canon states, "The Explorers of Light program is a group of forty-two of the world's best photographers, united in their love and passion for photographic excellence. They also share a common desire to contribute back to the industry with a willingness to share their vision and passion with others."

She received a BA in Photography from California State University, Sacramento, and has been photographing for more than twenty-six years. Her images have been featured in numerous magazines and books, and she also displays her images in galleries. Jennifer enjoys giving lectures and seminars as well as leading workshops for Canon and aFilm International Film Workshops. She leads tours to locations as varied as Namibia, Death Valley, Greenland, Montana, Alaska, Hawaii, Iceland, and Spain and makes Sacramento, California, her home base between adventures. View her images at www.jenniferwu.com.

JAMES MARTIN

James Martin has written and photographed professionally since 1989 with articles and photographs appearing in *Sports Illustrated*, *Smithsonian*, *Outside*, *Backpacker*, *Climbing*, *Boys' Life*, *Outdoor Photographer*, and many other publications. His most recent books are: *Photography: Outdoors* (Mountaineers Books) and *Planet Ice* (Braided River), a survey of ice that elucidates the relationship between climate and ice, and the action of ice on the landscape. He wrote *Masters of Disguise*: *A Natural History of Chameleons*, the first comprehensive book on chameleons in English, with photographs by Art Wolfe, and created a series of coffee table books on the mountains of the West, including *North Cascades Crest*, *Mount Rainier*, and *Sierra*. *Extreme Alpinism* (Mountaineers Books), written and photographed with Mark Twight, concerns techniques for climbing and surviving the most difficult mountains. He has also written books for children on natural history topics.

His travels have led him to Africa, Madagascar, Antarctica, Europe, and all southeast Asian countries, and he has hiked and climbed extensively. He has led photography tours around the world for Joseph Van Os Photo Safaris and now operates his own tours, both solo and in association with other photographers. View his images at www.jamesbmartin.com.

MOUNTAINEERS BOOKS

SKIPSTONE BRAIDED RIVER

recreation • lifestyle • conservation

Mountaineers Books is a leading publisher of mountaineering literature and guides—including our flagship title, *Mountaineering: The Freedom of the Hills*—as well as adventure narratives, natural history, and general outdoor recreation. Through our two imprints, Skipstone and Braided River, we also publish titles on sustainability and conservation. We are committed to supporting the environmental and educational goals of our organization by providing expert information on human-powered adventure, sustainable practices at home and on the trail, and preservation of wilderness.

The Mountaineers, founded in 1906, is a 501(c)(3) nonprofit outdoor activity and conservation organization whose mission is "to explore, study, preserve, and enjoy the natural beauty of the outdoors." One of the largest such organizations in the United States, it sponsors classes and year-round outdoor activities throughout the Pacific Northwest, including climbing, hiking, backcountry skiing, snowshoeing, bicycling, camping, paddling, and more. The Mountaineers also supports its mission through its publishing division, Mountaineers Books, and promotes environmental education and citizen engagement. For more information, visit The Mountaineers Program Center, 7700 Sand Point Way NE, Seattle, WA 98115-3996; phone 206-521-6001; www.mountaineers.org; or email info@mountaineers.org.

Our publications are made possible through the generosity of donors and through sales of more than 500 titles on outdoor recreation, sustainable lifestyle, and conservation. To donate, purchase books, or learn more, visit us online:

MOUNTAINEERS BOOKS
1001 SW Klickitat Way, Suite 201 • Seattle, WA 98134
800-553-4453 • mbooks@mountaineersbooks.org
www.mountaineersbooks.org

Mountaineers Books is proud to be a corporate sponsor of the Leave No Trace Center for Outdoor Ethics, whose mission is to promote and inspire responsible outdoor recreation through education, research, and partnerships. The Leave No Trace program is focused specifically on human-powered (nonmotorized) recreation.

Leave No Trace strives to educate visitors about the nature of their recreational impacts and offers techniques to prevent and minimize such impacts. Leave No Trace is best understood as an educational and ethical program, not as a set of rules and regulations.

For more information, visit www.lnt.org or call 800-332-4100.

OTHER MOUNTAINEERS BOOKS YOU MIGHT ENJOY

**Photography: Outdoors: A Field Guide
for Travel and Adventure Photographers**
Third Edition
James Martin
Learn to shoot high quality outdoor images
and master the latest photographic equipment
and software.

**North Cascades Crest: Notes and
Images from America's Alps**
James Martin

**Mount Rainier: Notes and images
from Our Iconic Mountain**
Text by John Harlin III
Photographs by James Martin

**Sierra: Notes and Images from
the Range of Light**
James Martin
Three stunning photography books that take
you on a visual journey through the craggy
crest of the North Cascades, the glaciers
and wilderness of Mount Rainier, and
the luminescent peaks of the Sierra Nevada.

Travels to the Edge: A Photo Odyssey
Art Wolfe
Revel in the beauty of awe-inspiring
landscapes and the unique animals and
people that inhabit them as captured
through the lens of internationally
acclaimed photographer Art Wolfe.

**Mountaineers Books has more than
500 outdoor recreation titles in print.**
For more details, visit www.mountaineersbooks.org.